THE URBAN SKETCHING HANDBOOK

DRAWING EXPRESSIVE PEOPLE
Essential Tips & Techniques for Capturing People on Location

RÓISÍN CURÉ

About This Series

The Urban Sketching Handbook series takes you to places around the globe through the eyes and art of urban sketchers. Each book offers a bounty of lessons, tips, and techniques for sketching on location for anyone venturing to pick up a pencil and capture their world.

Architecture and Cityscapes by Gabriel Campanario

People and Motion by Gabriel Campanario

Reportage and Documentary Drawing by Veronica Lawlor

Understanding Perspective by Stephanie Bower

The Urban Sketching Art Pack by Gabriel Campanario

Working with Color by Shari Blaukopf

101 Sketching Tips by Stephanie Bower

Drawing with a Tablet by Uma Kelkar

Techniques for Beginners by Suhita Shirodkar

Drawing Expressive People by Róisín Curé

The Complete Urban Sketching Companion by Gabriel Campanario, Stephanie Bower, and Shari Blaukopf

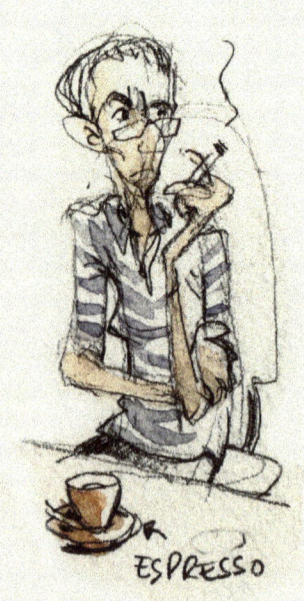

⊃ This powerful sketch of the artist's mother is, to me, what drawing expressive people is all about. One feels that this is a characteristic pose: The true master can capture all there is to know of a person's soul through line and simple gesture, without strict adherence to anatomical precision.

NICOLA MAIER-REIMER
Espresso
A5 (5¾" x 8¼" | 14.8 x 21 cm); pencil and watercolor.

CONTENTS

About This Series 2
Introduction 4

KEYS

I Tools & Supplies .. 7
II Challenges .. 17
III Proportions ... 43
IV Poses & Actions ... 61
V Color & Light .. 73

GALLERIES

I On the Move ... 94
II Light & Shadow .. 97
III Creative Color .. 100
IV Capturing Memories ... 105

Challenge Yourself 108
Contributors 109
Acknowledgments 111
About the Author 111

INTRODUCTION

A director went to shoot a movie in the desert. "There's nothing there!" people said. "How are you going to make a movie?" The director smiled. "I have the most interesting thing of all," he replied, "the human face."

Humans respond to other humans. We dream of each other and are enthralled by each other. Humans bring life and interest to a sketch and, when expressively drawn, we can't turn away. But drawing people is a challenge: They don't keep still, and we know what they're supposed to look like, which adds pressure. The reward, however, is worth the effort many times over. Once you get the hang of it, you won't want to stop, and you'll see stories unfolding everywhere.

The good thing about drawing people is that you will get lots of enjoyment out of your results, even at the beginning. The mind's eye will join the dots. A combination of lots of practice and lots of learning will help you observe and tame those subtle details that bring people to life.

In this book, I share some of the tricks that transformed my sketches from people-free zones to a joyful celebration of the color and life I see all around me. To capture another human in art in a fleeting moment of their journey may be challenging, but it is also a privilege. The fun is in the ride: Come aboard!

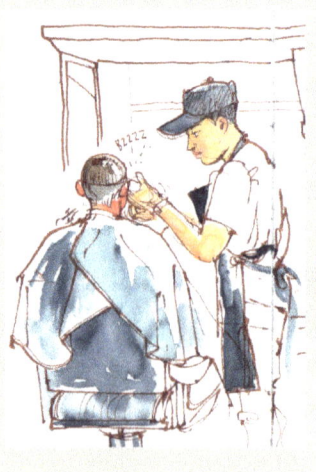

↶ Look at the body language of the two barbers. Can you guess which one owns his shop?

Brazilian Barber
A5 (5¾" x 8¼" | 14.8 x 21 cm)
Hahnemühle sketchbook, fude pen, brown ink, and watercolor.

↷ Reflections are hard in a live sketch—by the time you've drawn your subject, the reflection has moved.

Ali Concentrates
A5 (5¾" x 8¼" | 14.8 x 21 cm)
Fabriano Venezia sketchbook (double spread), fude pen, black ink, and watercolor.

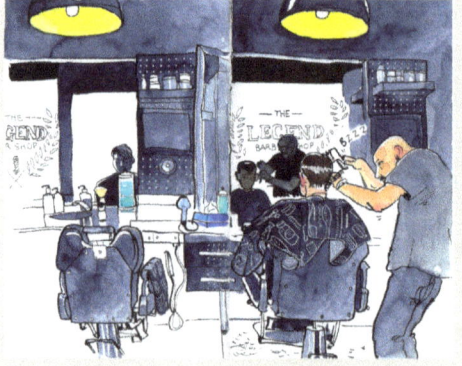

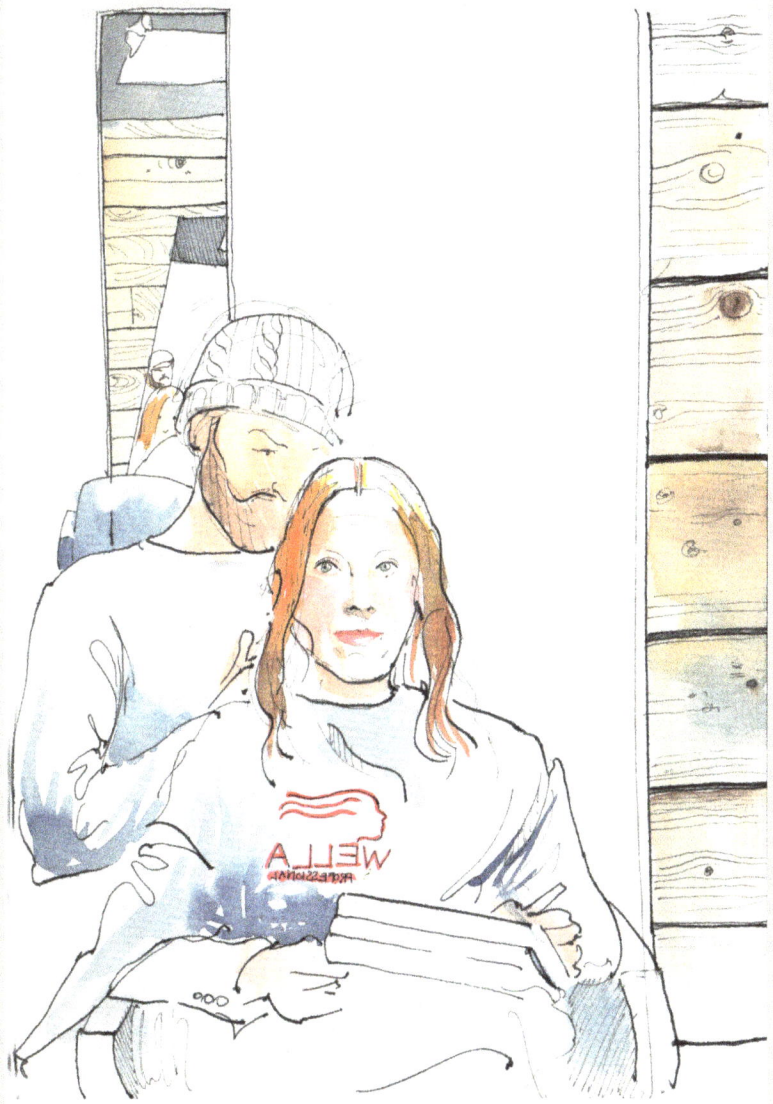

All artwork on this spread:
RÓISÍN CURÉ

🎧 You're forced to keep still for the hairdresser, so it's a fine chance for a self-portrait.

Urban Lane

11⅝" x 8⁵⁄₁₆" | 29.5 x 21 cm; fountain pen and watercolor.

SKETCH HERE!

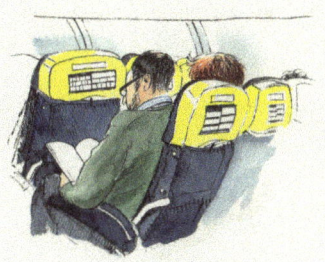

KEY 1
TOOLS & SUPPLIES

The thing about sketching people—who come and go—is that you never know when an opportunity will present itself, so it's good to be always prepared. Drawing people quickly in a candid manner is one of the best ways to get the practice you need to improve. If your bag is always ready, always within reach, and always stocked with paint, pens, paper, brushes, and water, the volume of work you produce will increase dramatically—and so will your skill.

⋂ RÓISÍN CURÉ
On the Plane to London
A4 (8¼" x 11½" | 21 x 29.7 cm),
brush pen and watercolor.

BASIC KIT: THE BARE ESSENTIALS

Because you may need to get to work fast and efficiently, your kit should be as small as possible. Have a bag always packed and ready: I have one with a kit that never changes because it works really well. I can fit everything into a small bag no bigger than my largest sketchbook (A4, or 8¼" x 11½" | 21 x 29.7 cm). But I can get away with a really tiny kit, if I find myself in cramped quarters. It's amazing how compact your kit can be! That said, tastes vary as much as sketchers: I have seen marvelous feats of athleticism in the hands of sketchers who use and exchange many different tools all at once, each finger holding a different color. I'm not quite so dexterous.

The minimum equipment I can get away with is as follows:
- Two waterbrushes, medium-sized (one for dark colors and one for light colors)
- An A5 (5¾" x 8¼" | 14.8 x 21 cm) or A6 (4⅛" x 5¹³⁄₁₆" | 10.5 x 14.8 cm) sketchbook with 200 gsm watercolor paper, stitched, rather than spiral bound
- A tiny metal box containing up to 13 half pans of artists' watercolor—make your own!
- Two bulldog clips with a magnetic surface
- A fude pen (55-degree nib brush pen) with waterproof brown ink (or any pen in any color)
- A tiny screw-top container for water with magnetic tape or tab on the bottom

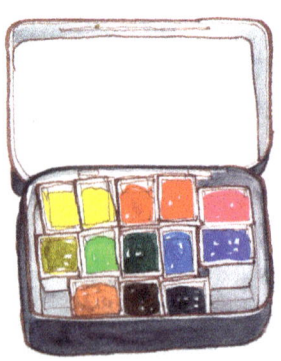

◐ A6 (4⅛" x 5¹³⁄₁₆" | 10.5 x 14.8 cm) sketchbook (small enough for anywhere).

◐ Tiniest paint kit. ◑ My beloved fude pen (*fude* meaning *brush* in Japanese).

Key 1: Tools & Supplies | **9**

◐ A waterbrush can go where no water containers are allowed.

◔ A tiny water container.

Tip

Make your own mini paintbox. Fill empty half pans with paint from tubes and secure them inside an Altoids tin or a small craft tin with strips of magnetic tape. Paint the lid with enamel paint for a nice mixing surface.

◔ A magnetic clip for attaching paintbox.

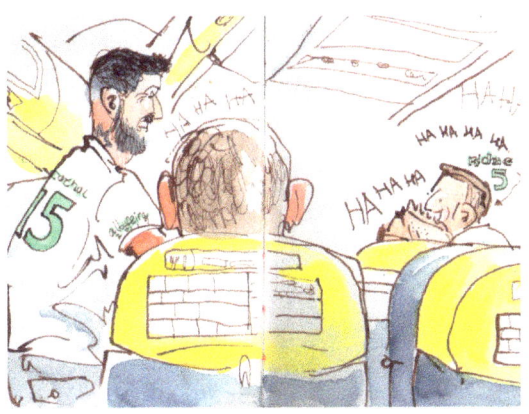

◔ I was able to draw these guys on a plane to Portugal discreetly—not that they would have noticed anyway.

RÓISÍN CURÉ
The Stag Party

A6 (4⅛" x 5¹³⁄₁₆" | 10.5 x 14.8 cm) (double spread); Hahnemühle watercolor sketchbook, fude pen, brown ink, and watercolor.

Larger Kit: For Any Eventuality

↻ An A5 (5¾" x 8¼" | 14.8 x 21 cm) and an A4 (8¼" x 11½" | 21 x 29.7 cm) sketchbook. I like to have a choice, and an A5 portrait and an A4 landscape format allows for lots of possibilities. Don't forget absorbent paper.

⊃ Vials of extra ink in your colors of choice. Nothing is worse than running out of ink, and the one drawback of a fude pen is that it's an ink guzzler. I have learned the hard way never to forget extra ink. I use waterproof ink, because I always paint my figures. I use brown because it's softer than black and mistakes won't be as glaring.

☋ Fude pens—at least two pens for two colors (I pack four or five). You'll have your favorite pens, but it's hard to beat the versatility of the fude pen with its variety of line widths.

↷ Carbon pen (any pen with a very fine nib). This is great for scribbling a shape before you have found your confident zone. The thin, scribbly lines won't be noticed once you have painted.

☋ Two white gel pens: one with a fine nib, one with a broad one. These are great for all kinds of uses, but for people I use them to correct imperfections in my likeness. They are also great for white patterns on clothing.

⊃ Larger paintbox with up to 24 colors. The color choice is up to you; I change mine a bit every so often. Your choice is as much part of your artistic voice as your line. As long as your choices cover most bases, you will be fine.

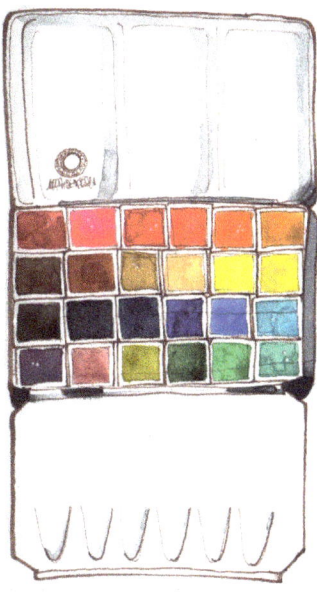

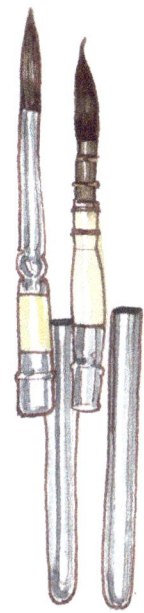

⊂ Two travel brushes, medium size with good points. One is a squirrel mop, the other a sable-nylon mix. The squirrel brush is wonderful for expressive washes, because it holds loads of liquid or paint, and the nylon-sable blend is lovely for finer work.

◒ Magnetic clips are great for attaching your paintbox to your sketchbook.

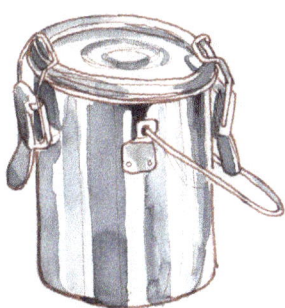

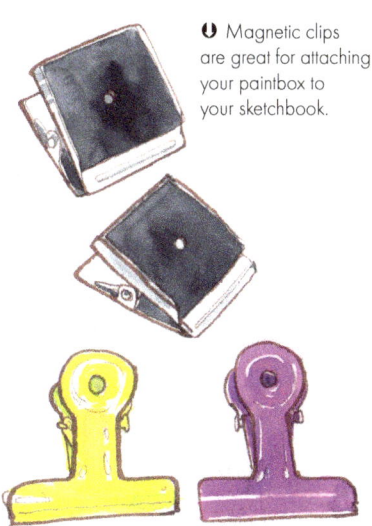

◓ A stainless steel, leakproof container "brush washer." This is an indestructible water container; it won't spill or leak and is large enough for thorough, vigorous brush washing. More water means longer time before you have to change it.

Drawing Expressive People

⊃ Between a carbon pen, a fude pen, and a white gel pen, you have endless opportunities to capture a wide variety of line.

> **Tip**
>
> A pen forces you to accept your mistakes and accelerates your progress in finding your voice. Using thin, scribbly lines followed by a more confident line is a gentle introduction to using a pen.

⊃ Search lines can add a lot of life to a sketch: The fast, lively wash is the squirrel brush.

RÓISÍN CURÉ
Paddy in His Apron
A4 (8¼" x 11½" | 21 x 29.7 cm)
Hahnemühle 200g, ink, and watercolor.

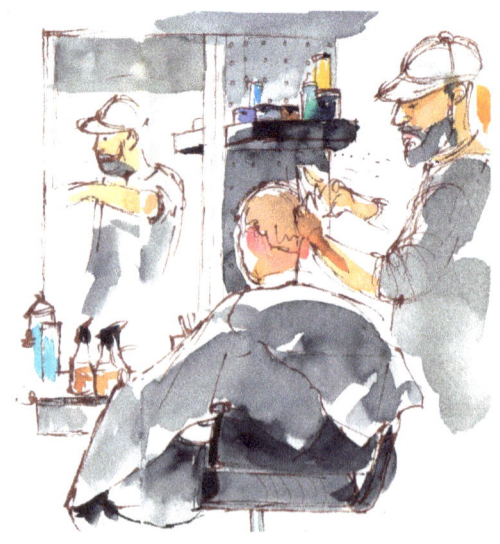

⊃ The flattened nib of a fude pen offers great variety of width, as well as speed. The resulting lines are a good balance between the expressivity of a brush pen and the convenience and control of a fountain pen.

RÓISÍN CURÉ
Barber at Work
A5 (5¾" x 8¼" | 14.8 x 21 cm)
Hahnemühle watercolor book, fude pen, brown ink, and watercolor.

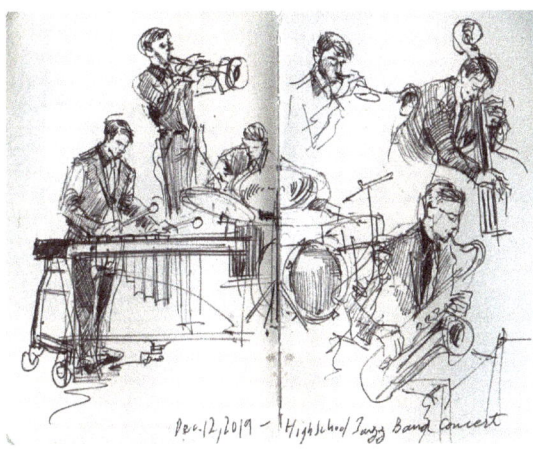

☛ A ballpoint pen is a cheap and readily available tool, capable of great sensitivity.

GABRIEL CAMPANARIO
High School Jazz Band Concert

3½" x 5½" | 8.9 x 13.9 cm
Stillman and Birn pocket sketchbook (Epsilon series), BIC Cristal ballpoint pen.

Tip

If you like to scan your images, choose a page size that fits on the bed of an A4 scanner, and lies flat—not that you'll base your choice of sketchbook on your scanner, but it will save you lots of time and effort.

☚ Brush pen and black ink combine to catch the vital energy of this band. You can sense the volume!

SYLVAIN CNUDDE
Grandma's Ashes

A4 (8¼" x 11½" | 21 x 29.7 cm); Chinese ink brush pen.

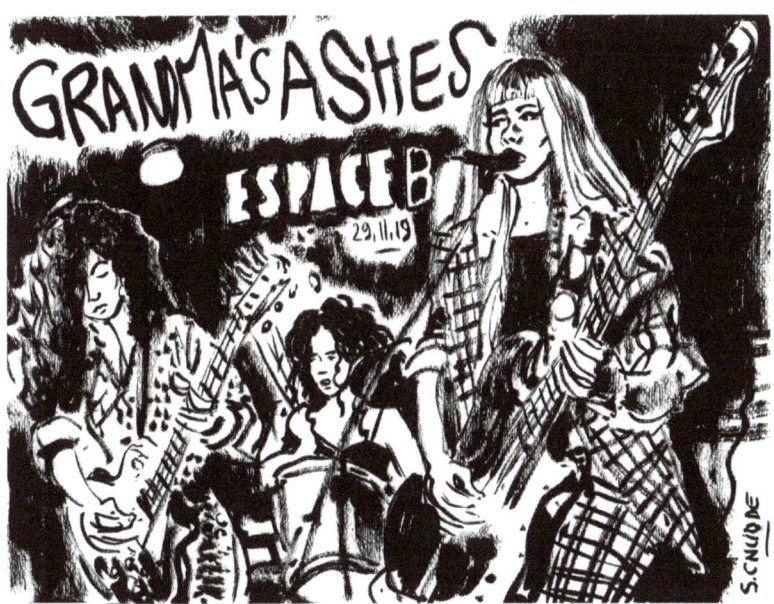

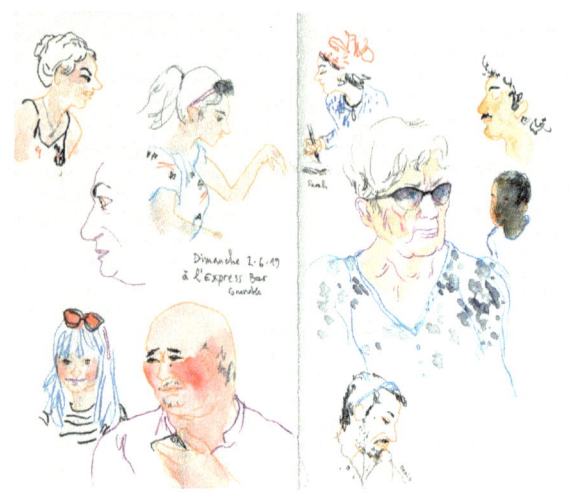

◯ MARIELLE DURAND

L'Express Bar, Grenoble

A5 (5¾" x 8¼" | 14.8 x 21 cm); colored pencils and watercolor.

"I draw very quickly on the Paris metro, on trips, or in cafés. It's one of the best forms of training I know, and I've been doing it for more than twenty years. I don't want a recipe; I always use different methods. I like using colored pencils, ink, felt-tip—anything. I find strangers easier than friends or family, but I never get bored of sketching people." —Marielle Durand

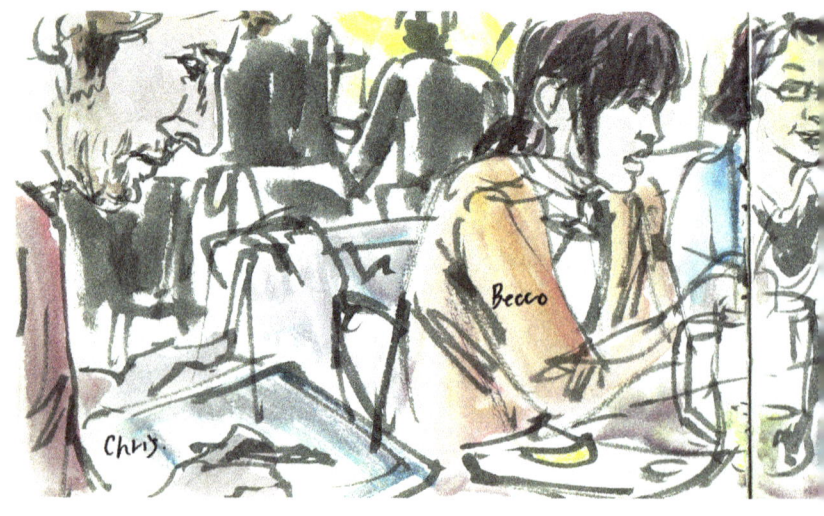

Key I: Tools & Supplies | 15

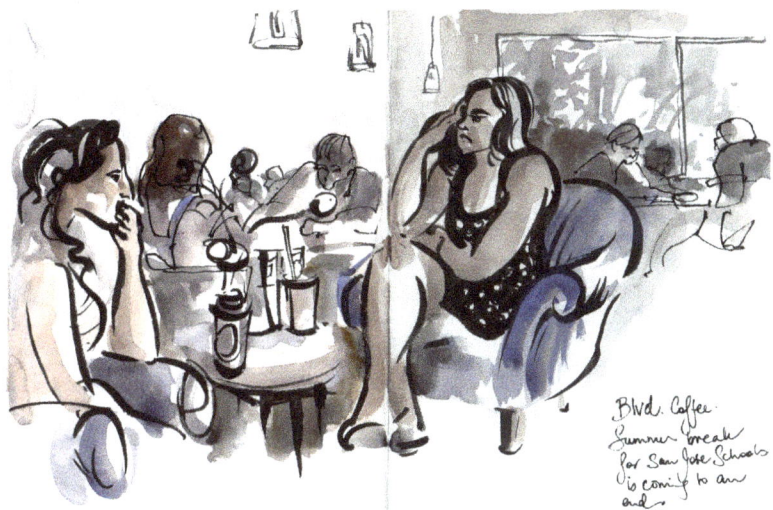

↷ Great movement is brought to this sketch by brush pen, in the artist's distinctive loose style.

SUHITA SHIRODKAR
*Boulevard Coffee
in San José*
18" x 7" | 45.7 x 17.8 cm;
watercolor and brush pen.

↶ **KUMI MATSUKAWA**
D&D in a Japanese Pub
16½" x 5¾₁₆" | 42 x 13.3 cm
Hahnemühle travel sketchbook,
watercolor, and black brush pen.

*"I draw lines
with a black brush
pen and then
add color."*
—Kumi Matsukawa

SKETCH HERE!

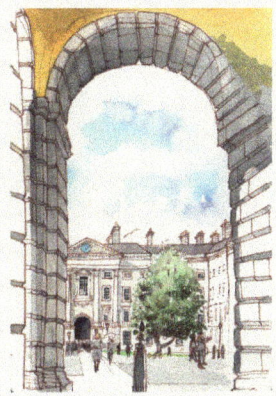

KEY II
CHALLENGES

As if drawing the delicate lines of a human face and body isn't hard enough, your human subject makes it harder by disappearing mid-sketch. This can be a blessing in (heavy!) disguise, challenging your brain to rise to the challenge. The self-critical, fussy part of the brain stays silent and allows the joyful, exuberant part to take charge. The inhibitor becomes inhibited. Still, you do need a certain minimum amount of time to sketch before your subject moves, or you will have nothing to show for your effort. This chapter presents some of the ways I solve the challenges presented by living, breathing subjects with a will and opinions of their own—and no compunction to stay until you're finished!

But there's another factor to consider. For many, drawing people is scary. I still get a few butterflies sometimes. However, if it's true that you can get used to anything, then the more you try, the calmer you'll be.

⋒ RÓISÍN CURÉ
Under the Campanile, Trinity College Dublin
A4 (8¼" x 11½" | 21 x 29.7 cm); fude pen, ink, and watercolor.

FEAR OF DISCOVERY

However wonderful it would be to be invisible when we sketch strangers, it's not going to happen. We're taught that it's rude to stare—and it kind of is—but you have to stare to sketch. Be subtle and, failing that, be honest, and use humor to break the ice. If humor doesn't feel right, politeness will do. Here are some tips:

- If you think you've been spotted, avert your gaze and pretend you're drawing something else (so much for honesty).
- Say, "Sorry, I haven't done you justice at all!" or "I hope you like the new legs I've given you; they belonged to the last guy!"
- Solicit their help: Say, "I need a figure to give a sense of scale to my drawing: I hope you don't mind if I include you?"
- If the person you're drawing is approaching and you sense that they're going to have a look, but you don't want them to see your sketch of them, move the magnetic clips over your drawing and let the paintbox cover the figure.

All artwork on this spread:
RÓISÍN CURÉ

☉ Draw in the airport; everyone is in their own bubble, and the last thing they care about is whether someone is drawing them.

Santiago de Compostela Airport
A5 (5¾" x 8¼" | 14.8 x 21 cm)
Hahnemühle 200g watercolor sketchbook (double spread), fude pen, and watercolor.

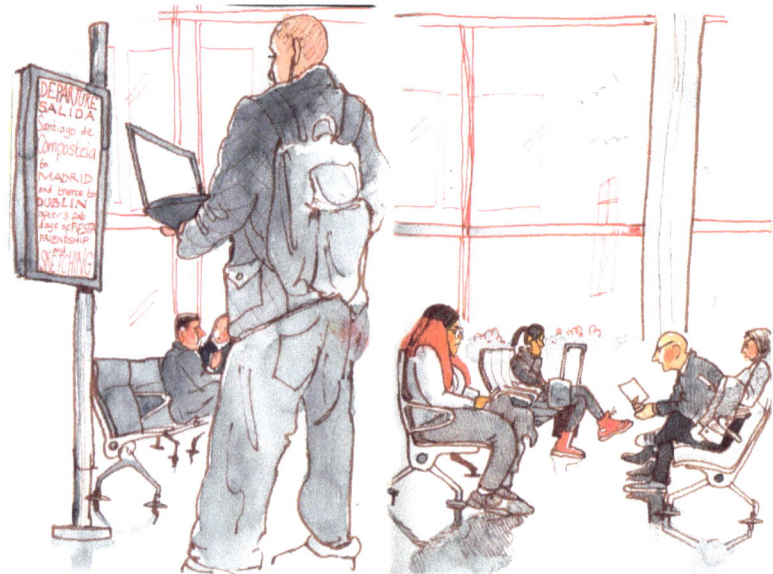

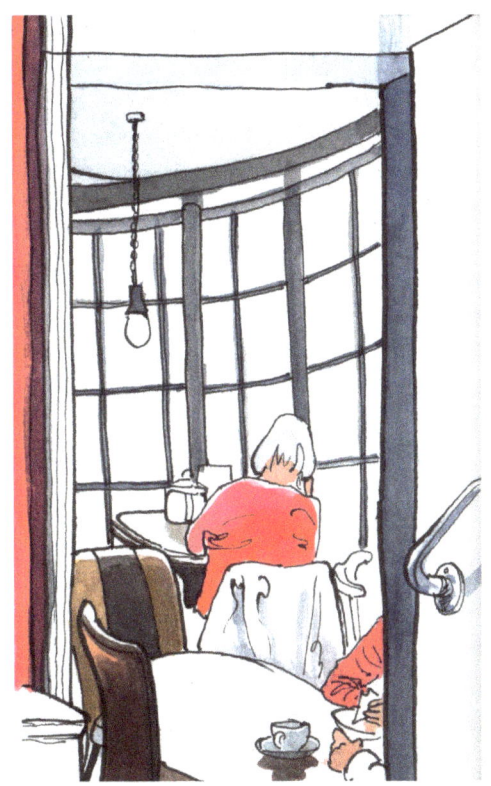

☛ A great way to ease yourself into drawing strangers in public is to draw them from behind. Most people are too engrossed in their daily lives to notice they're being drawn. Women sketchers are less likely to be noticed than men, who, for their part, appear to be less concerned about being discovered. People chatting, reading, using their phone, or deep in thought make great subjects to draw discreetly.

Apothecary Café, Rye, East Sussex
A5 (5¾" x 8¼" | 14.8 x 21 cm)
Fabriano Venezia sketchbook, fude pen, waterproof ink, and watercolor.

↺ This man was dozing in the sun and his interaction with his dogs was very touching.

His Best Friends
8½" x 4½" | 21.5 x 11.5 cm
Fabriano Venezia sketchbook, fude pen, ink, and watercolor.

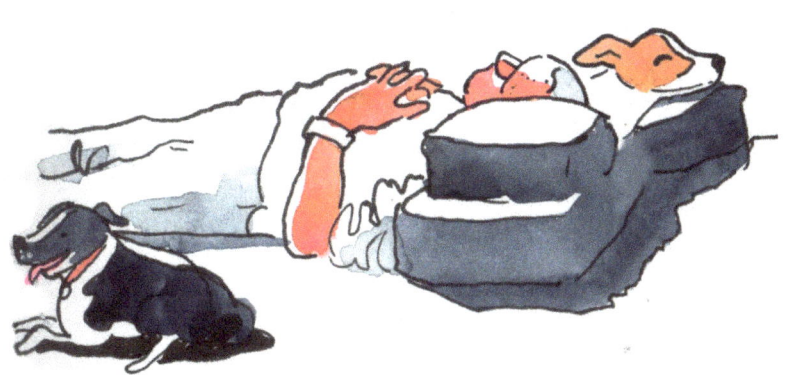

SUBJECTS MOVING

Humans in an urban sketching setting move, and you must develop a box of tricks to deal with that. One way to get used to movement is to ease in gently by drawing musicians, who might not move more than their arms.

- Wait for it. Many moving subjects take the same pose again and again, giving you lots of chances to draw it. It can feel like an eternity when you are mid-flow, but you have to wait.
- Draw one line at a time. Capture the flash of an arm. The angle of a jaw. The tilt of the head.

All artwork on this spread:
RÓISÍN CURÉ

➲ Even the fluffy chicken turned back to the same position again.

Organ Grinder and His Troupe, Porto

6³⁄₁₀" x 6³⁄₁₀" | 16 x 16 cm
Fabriano 300g paper on home-made concertina sketchbook, fude pen, ink, and watercolor.

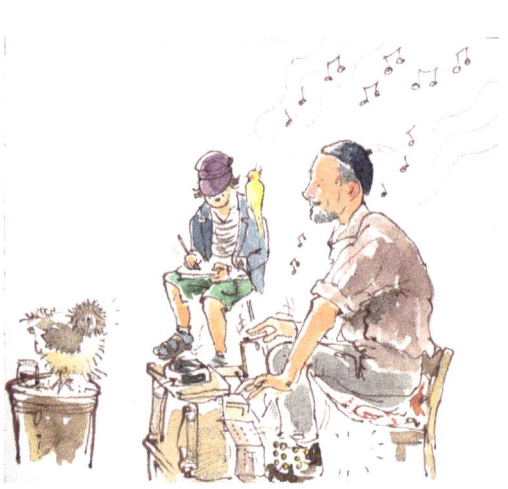

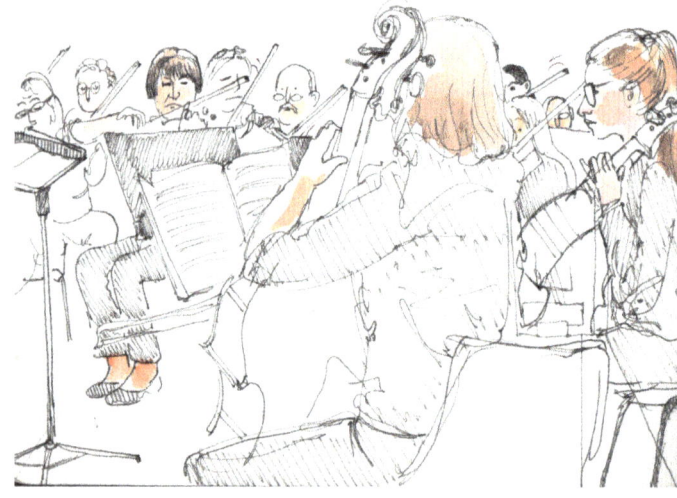

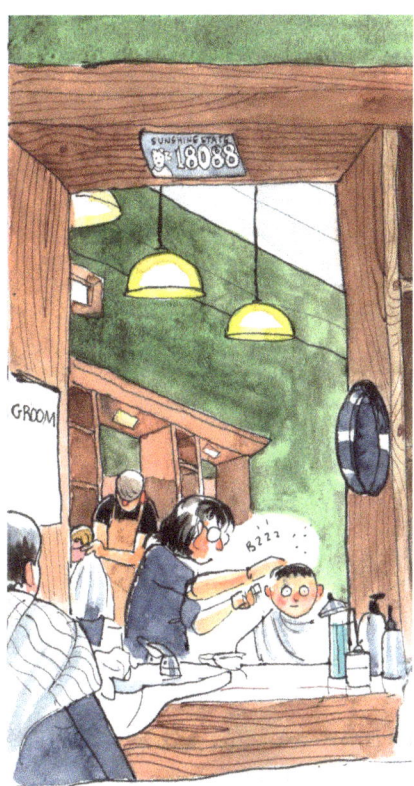

◐ Sketching in the barbershop is challenging and forces you to be patient and wait until the barber takes the position again.

Quick on Their Feet
A5 (5¾" x 8¼" | 14.8 x 21 cm) sketchbook, fude pen, and watercolor.

◉ This was one of my earliest sketches of a group (though I didn't take in much of the music). Decide on the pose you like, then stick to it. Even if members of a group scramble around a bit, they will likely return to their pose.

St. Agnes Chamber Orchestra
A5 (5¾" x 8¼" | 14.8 x 21 cm) landscape sketchbook, carbon pen, and black ink.

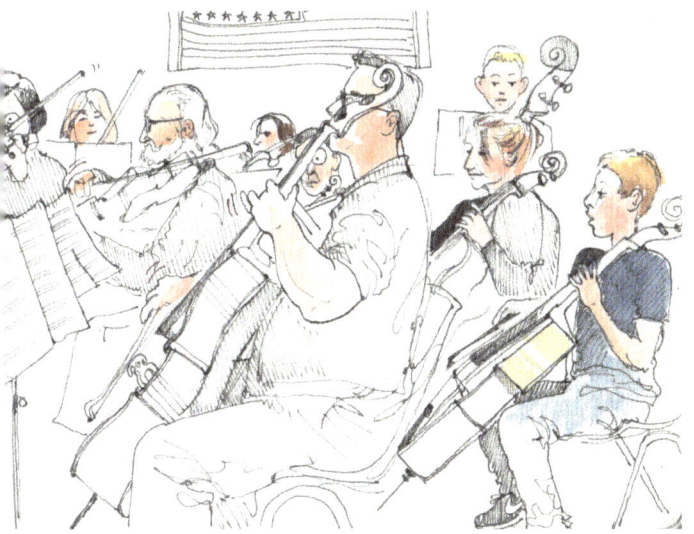

◐ If your subject is moving and you can't decide which limb to pick, draw both in a thinner or sketchier line. You can either decide which one to develop or give your subject an extra limb, which adds life and quirkiness to your sketch. It's almost a micro-video.

Honor Studying Geography
A5 (5¾" x 8¼" | 14.8 x 21 cm)
Fabriano Venezia sketchbook, fude pen, ink, and watercolor.

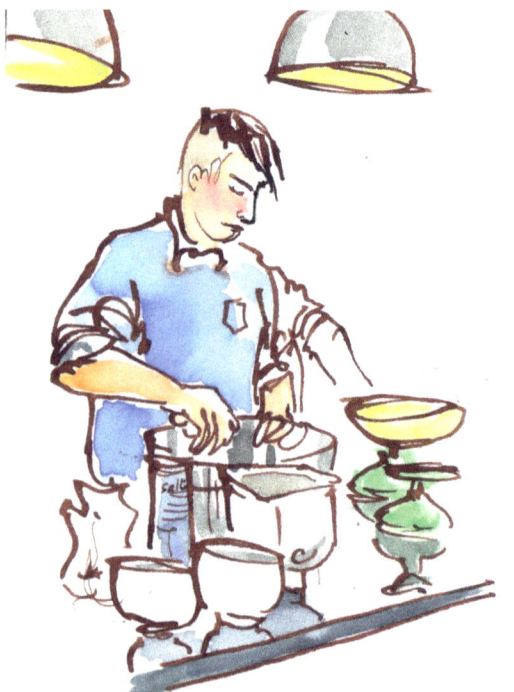

◐ Multiple limbs suggest a living, breathing subject.

Paddy Makes Bread
A5 (5¾" x 8¼" | 14.8 x 21 cm)
Fabriano Venezia sketchbook, fude pen, ink, and watercolor.

Walking

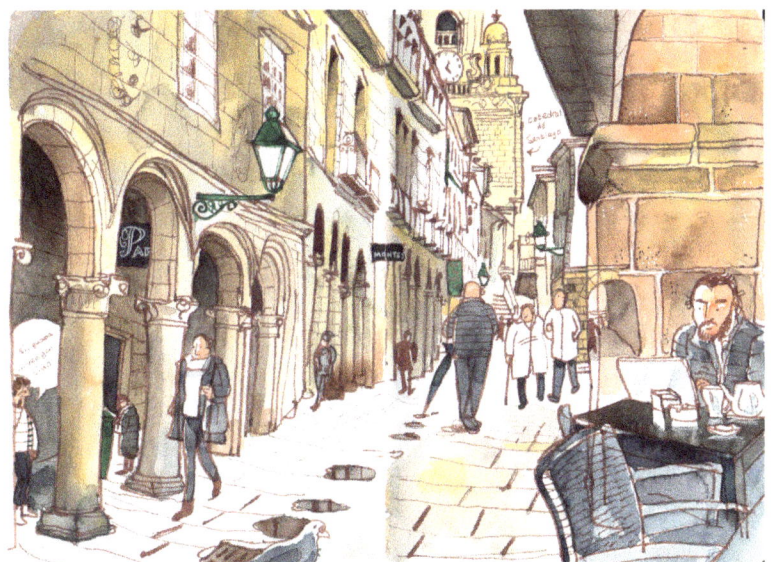

↻ It can be very difficult to draw someone walking, whether it's away from you or toward you. Take a mental snapshot: See where the top of the head meets the background at that point, try to do the same with the feet, then fit the figure between them.

Wet Streets of Santiago de Compostela
A5 (5¾" x 8¼" | 14.8 x 21 cm) Hahnemühle watercolor sketchbook, fude ink, and watercolor.

Dancing

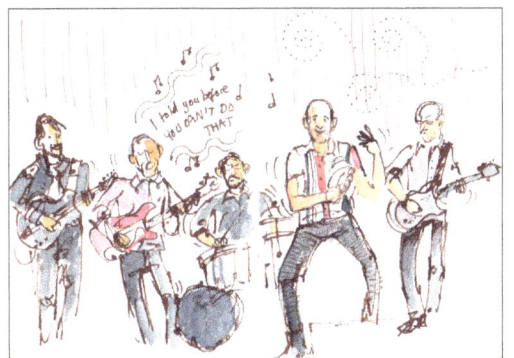

↻ A lively pop group is a great chance to practice sketching moving people. They might do all sorts of antics on stage, but you can be sure they'll come back; they won't leave the stage.

Los Fabulosos Weekend
A5 (5¾" x 8¼" | 14.8 x 21 cm) Hahnemühle watercolor sketchbook, fude pen, ink, and watercolor.

Tip

Using a limited color palette increases your chance of finishing the sketch on the spot.

All artwork on this spread:
RÓISÍN CURÉ

SUBJECTS LEAVING

You're getting on really well with your subject. You've managed the twists and turns and moving about. Then they get up and walk away. What do you do? It's time to become a mix of Sherlock Holmes and Dr. Frankenstein. First, be a shrewd detective like Sherlock Holmes. Before choosing your subject, decide whether the person is likely to stick around long enough to be sketched. Then, if you run out of time, become a mad scientist like Dr. Frankenstein: Substitute other people's body parts for the one you've just lost.

⊃ Drawing in a market is exhilarating but you are very unlikely to get cooperative subjects who stay still. Make composites of lots of bodies. The funny thing is it's actually hard to find body parts that match. We really are unique.

RÓISÍN CURÉ
Grote Markt, Haarlem, The Netherlands

A5 (5¾" x 8¼" | 14.8 x 21 cm) Hahnemühle watercolor sketchbook (double spread), fude pen, brown ink, and watercolor.

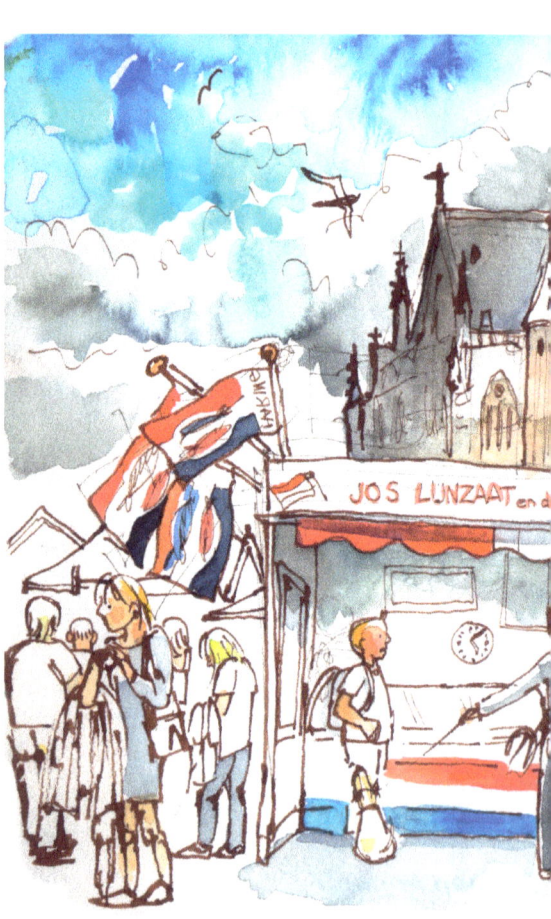

Tip

Watch people's glasses and cups. How much drink do they have left? If they're nearly finished, maybe it's better to choose someone else.

Ask the server whether the customer will be there for a while longer. They'll know and will be willing to help.

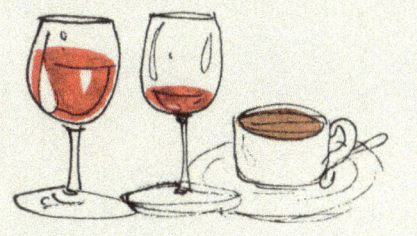

⊃ Sometimes a figure can be made of many people, all mixed into one, such as this man. He started out bald, but someone arrived with more hair. Some tips for mixing and matching:

- Never expect perfection; a complete figure is enough.
- Resist taking a photo. Better to choose someone else than have a stiff, lifeless figure.
- Don't wait for a similar person who looks like a good match; you won't get one.
- Speed is of the essence. Get the basic lines down in whatever is your choice of drawing implement.

Traitor's Gate, Dublin (detail)
A4 (8¼" x 11½" | 21 x 29.7 cm) Hahnemühle watercolor paper, fude pen, ink, and watercolor.

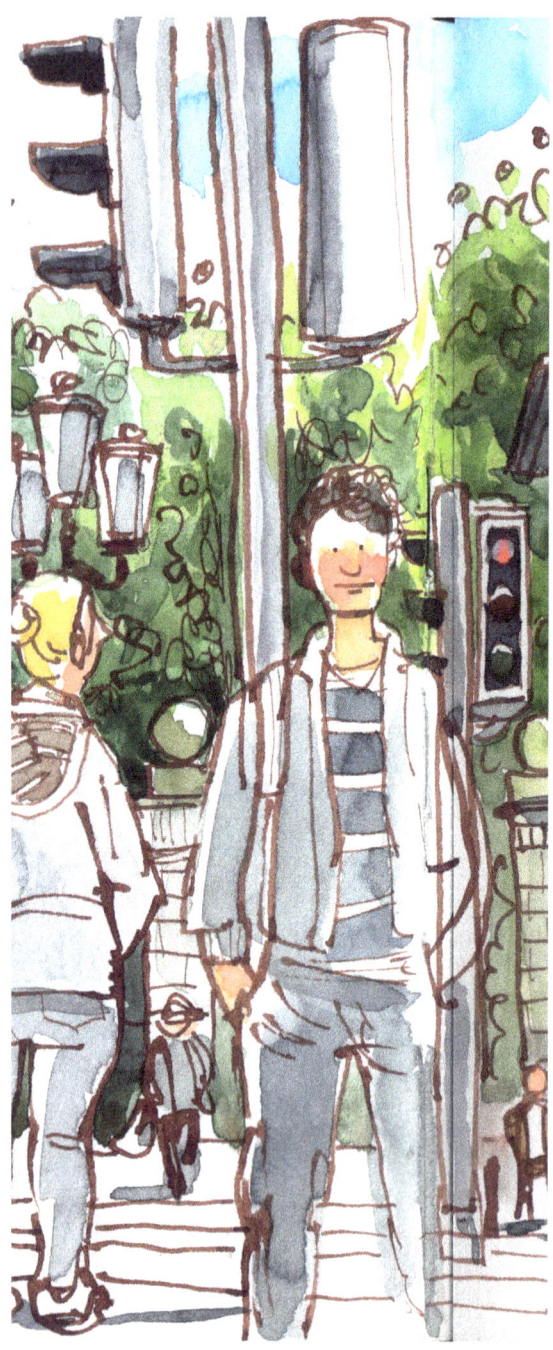

🎧 If you see a figure you like, draw the outline and then the bit that will change most radically: the shadow. I immediately outlined the pattern the sun made on this man's shirt, knowing he could wake up and leave at any second.

Sun in Stephen's Green, Dublin (detail)
A4 (8¼" x 11½" | 21 x 29.7 cm)
Hahnemühle sketchbook, fude pen, ink, and watercolor.

All artwork on this spread:
RÓISÍN CURÉ

Is It Helpful to Sketch from Photos?

It might seem sensible to take a quick snap of your subject before they disappear. Don't give in to temptation. Here's why:

- The play of light, and all lines and shapes, are much more clear in real life than in a photo.
- You break your concentration—and your subject may move anyway—in the time you get out your camera.
- A camera is a poor reproduction of real life.
- The sense of urgency, even panic, you feel when you draw a person who might flee is a large part of the reason you'll do a better job, as you won't fuss about the results. Inhibit the inhibition.
- That adrenaline rush is part of the fun!
- You can get the bits you miss with the next person.
- Photos are the enemy of lively sketches. Leave the phone in your pocket.

CHOOSING THE RIGHT SUBJECTS

We've now established that we're nervous to draw strangers, that subjects move, and that they disappear. That's enough trouble already! But there's worse: Humans come with opinions and attitudes. Think of your subjects as elusive butterflies, and your mission as a hunting expedition: We must know our quarry.

Strangers

In some ways, strangers are easy; they'll probably never be the wiser that they've been drawn and so don't come with attitude. But neither do they care that you have a sketch to finish.

↻ Sketching people on their phones is an opportunity to practice tilted heads, fingers, hunched shoulders, and lowered gazes.

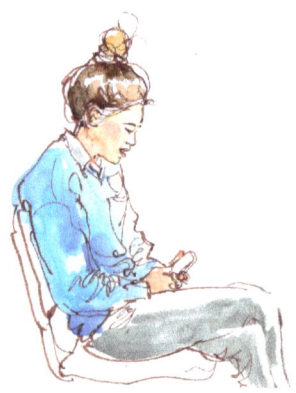

> **Tip**
>
> Public transport is a great place to capture strangers. They're captive, and they don't move much.

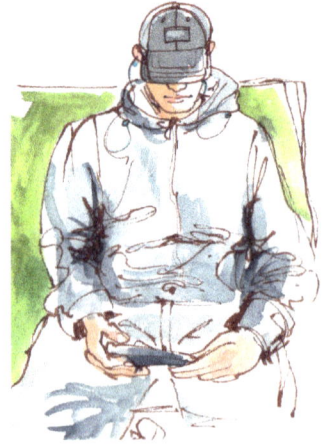

All artwork on this spread:
RÓISÍN CURÉ

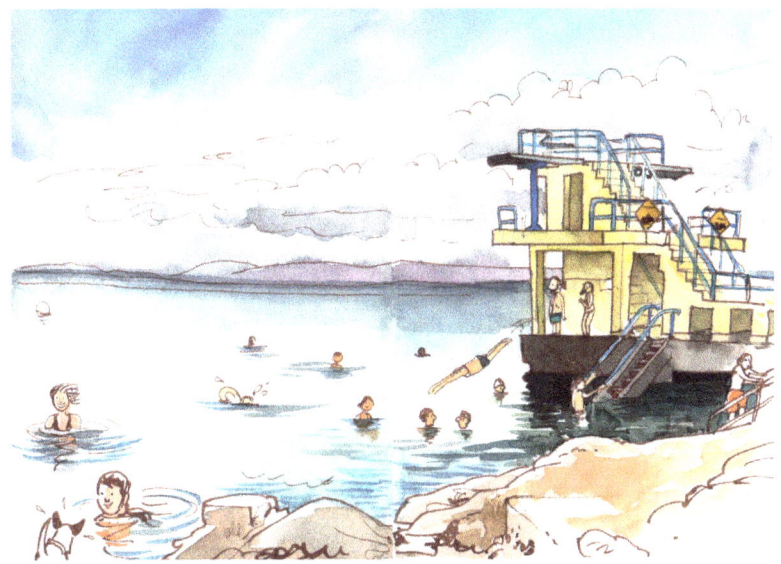

🎧 If someone is stuck—in the sea, or in a very slow queue, for example—they can't move too fast.

Daily Swimmers, Blackrock, Galway

A5 (5¾" x 8¼" | 14.8 x 21 cm) Hahnemühle watercolor sketchbook (double spread), fude pen, ink, and watercolor.

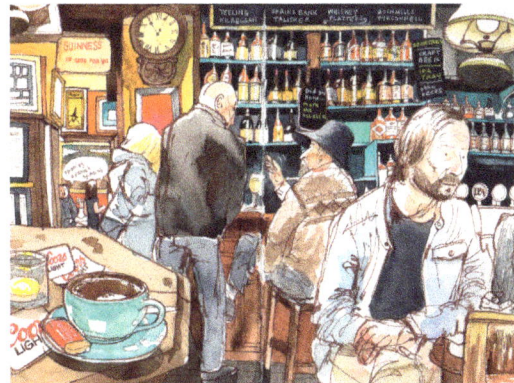

Is It Right to Sketch a Stranger?

Some people feel uneasy sketching a person without their explicit permission. Others think that it is no big deal, that anyone is game—and that there is a good chance they will unwittingly end up in someone else's photos anyway. You'll find the line beyond which you feel uncomfortable. For me, that line is anyone who is vulnerable, unless it's my family, because there's a bond of love and trust there, and they'll be quick to let me know if they're not happy.

🎧 You don't need to be very far from a group for them not to notice they're being sketched. A lively chat is a great scene to capture, and with a bit of luck you will get a close-up too.

Neachtain's, Galway

A5 (5¾" x 8¼" | 14.8 x 21 cm) Hahnemühle watercolor sketchbook (double spread), fude pen, ink, and watercolor.

Waiting

We all have unexpected delays. Many sketchers, whether they are drawing people or not, welcome an enforced wait, as it's a chance to get out the sketching kit, slow down, and chill out.

⊃ Drawing from an upper balcony is fun; no one ever looks up, and it's a good opportunity to practice incognito drawing. As a bonus, the foreshortening forces you to look honestly.

Waiting, Galway Clinic

A5 (5¾" x 8¼" | 14.8 x 21 cm) Fabriano Venezia sketchbook, fude pen, ink, and watercolor.

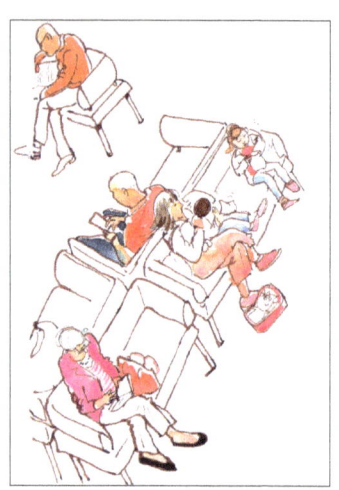

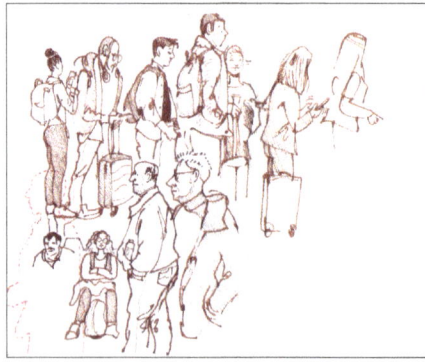

↻ Draw during a wait for a delayed flight and you'll never feel frustrated again.

Waiting in Madrid

A5 (5¾" x 8¼" | 14.8 x 21 cm) Hahnemühle watercolor sketchbook, fude pen, and ink.

↻ A long wait for a flight was greatly improved by sketching over a relaxing drink in the afternoon sun.

Jen and Cinnie in Faro Airport

A5 (5¾" x 8¼" | 14.8 x 21 cm) Hahnemühle watercolor sketchbook, fude pen, ink, and watercolor.

> **Tip**
>
> Sit down and sketch until the queue to board a plane is moving past. You'll get lots of subjects in that time.

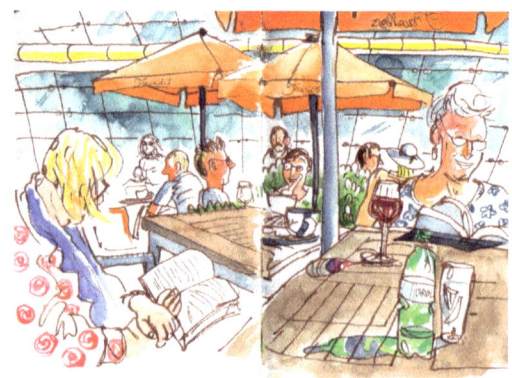

People Working

There are loads of places where you can draw someone at work relatively discreetly. Here are just a few suggestions:
- Staff at restaurants and bars
- Barbers and hairdressers
- Theater staff
- Craftspeople
- Vendors
- Flight attendants

All artwork on this spread:
RÓISÍN CURÉ

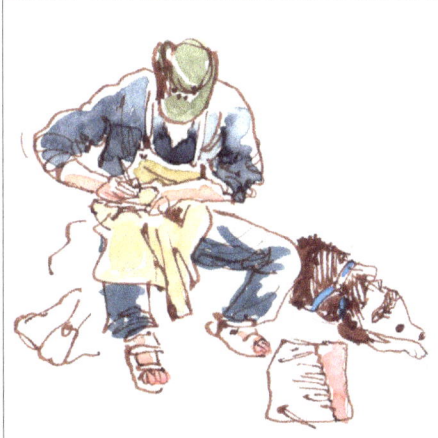

↺ Always ask yourself if the weight is distributed evenly or on one leg and depict that in the sketch.

Dáithí Carving Slate

A5 (5¾" x 8¼" | 14.8 x 21 cm) Fabriano Venezia sketchbook, fude pen, ink, and watercolor.

↺ Waitstaff are often glamorous and might be dressed in a way to pick up the decor of the café or restaurant.

Café Klimt, Vienna

A5 (5¾" x 8¼" | 14.8 x 21 cm) sketchbook (double spread), fude pen, ink, and watercolor.

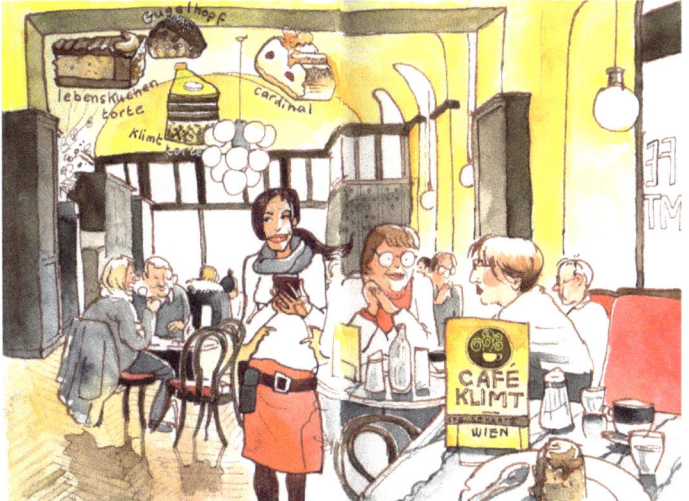

Family

Before the age of photography, it was common to sketch one's family. How else would you show what someone's beau looked like or how tall everyone had grown? And skill level was irrelevant. Nowadays, sketching your family can be difficult. They might object. They might take offense. You might be disappointed with the results, because you know how they should look. The answer is repetition. Draw them a lot and you'll get used to their lines.

➲ Children—with their eagerness to please—can keep surprisingly still.

Paddy mixing concrete, County Galway, Ireland
A5 (5¾" x 8¼" | 14.8 x 21 cm) Fabriano Venezia sketchbook, fude pen, ink, and watercolor.

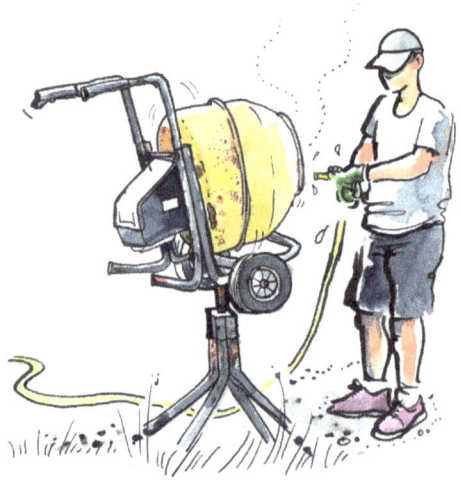

➲ Moments when young and old are together are very special, if you can capture them.

Erika and Olivia
A5 (5¾" x 8¼" | 14.8 x 21 cm) Hahnemühle watercolor sketchbook, fude pen, ink, and watercolor.

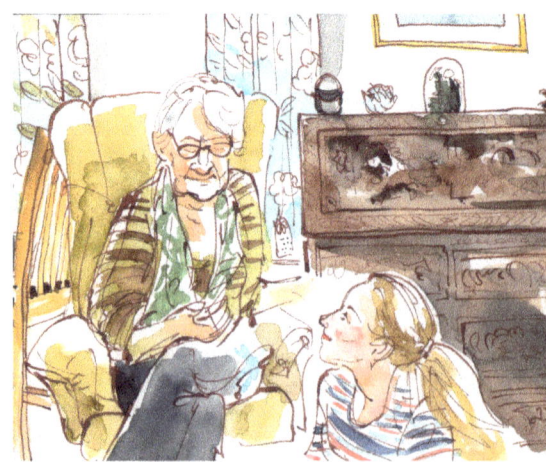

All artwork on this spread:
RÓISÍN CURÉ

⮕ A story being told, cooking side by side, or reading together are beautiful moments to capture.

Granddad and Olivia Make Chocolate Sauce

A5 (5¾" x 8¼" | 14.8 x 21 cm) sketchbook, pencil, and watercolor.

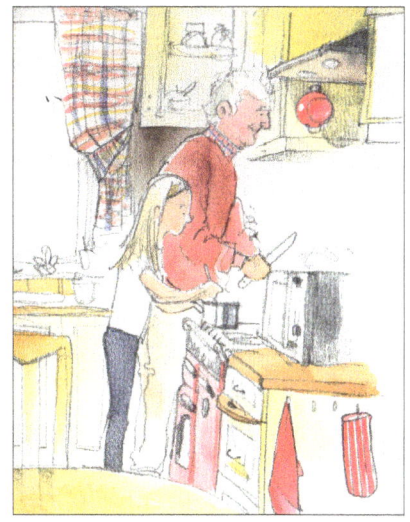

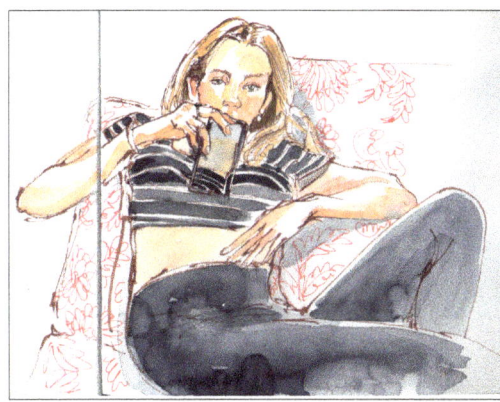

⮐ Teenagers can spend a long time on their phones; make the most of the unmoving opportunity they present to capture a typically youthful pose.

Olivia and Honor on Their Phones

Both images: A4 (8¼" x 11½" | 21 x 29.7 cm) Hahnemühle sketchbook, fude pen, ink, and watercolor.

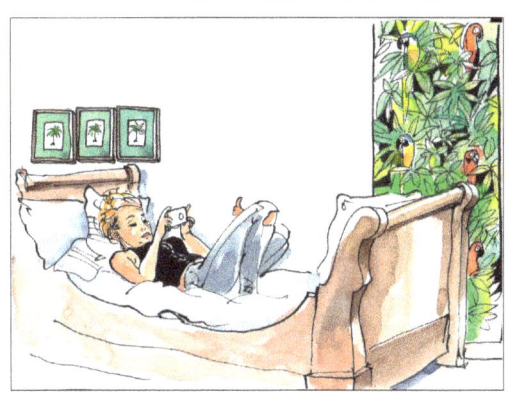

Tip

Incentivize: A reward of some sort will mean you'll have a willing model. Some may call it a bribe. That's okay.

Gatherings

To have a sketch of a family gathering is even better than a photo. It's the ideal way to capture the mood and much less intrusive than a photo, although you could argue that the people will be more used to a camera being stuck in their face.

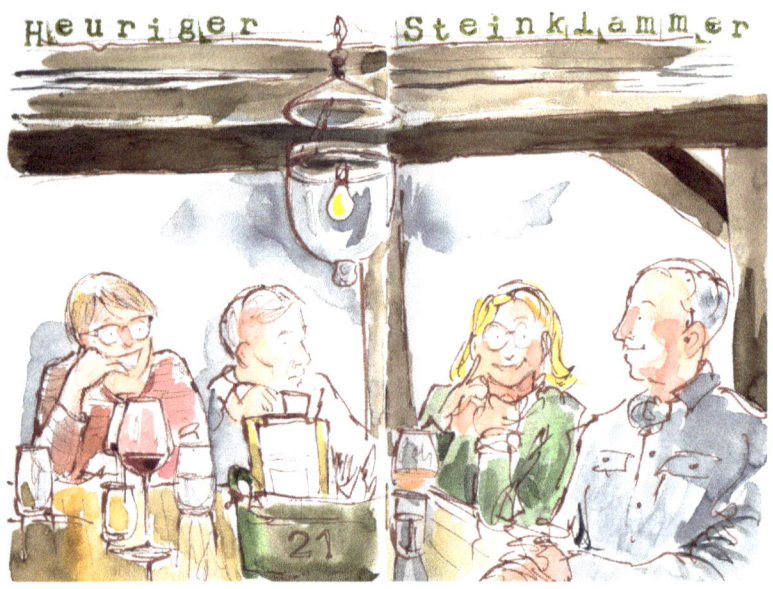

◐ No one will notice you sketching in a family group, and the convivial atmosphere can help make you feel more relaxed. In time, you might look back on your family sketches and think of the ones who are no longer around.

All artwork on this spread:
RÓISÍN CURÉ

Heuriger in Vienna, Austria
A5 (5¾" x 8¼" | 14.8 x 21 cm)
Hahnemühle watercolor sketchbook, fude pen, ink, and watercolor.

Tip

Choose a moment before the food has arrived. Everyone is still there, there's room for your kit, and you won't have had a chance to spill anything on your sketch yet.

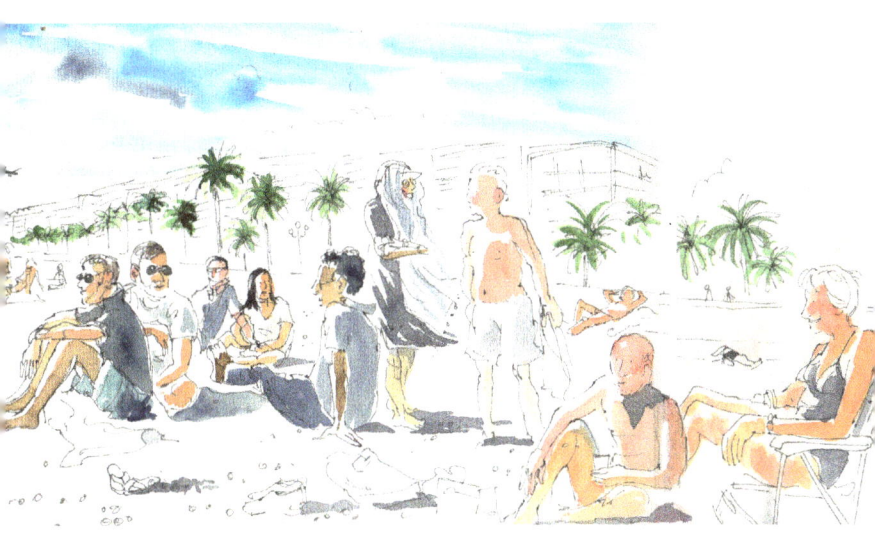

🎧 A sketch may not be your best effort in terms of drama or impact, but if it contains your loved ones, it will mean a lot to you.

Family Group, Nice, France
A4 (8¼" x 11½" | 21 x 29.7 cm) sketchbook, carbon pen, ink, and watercolor.

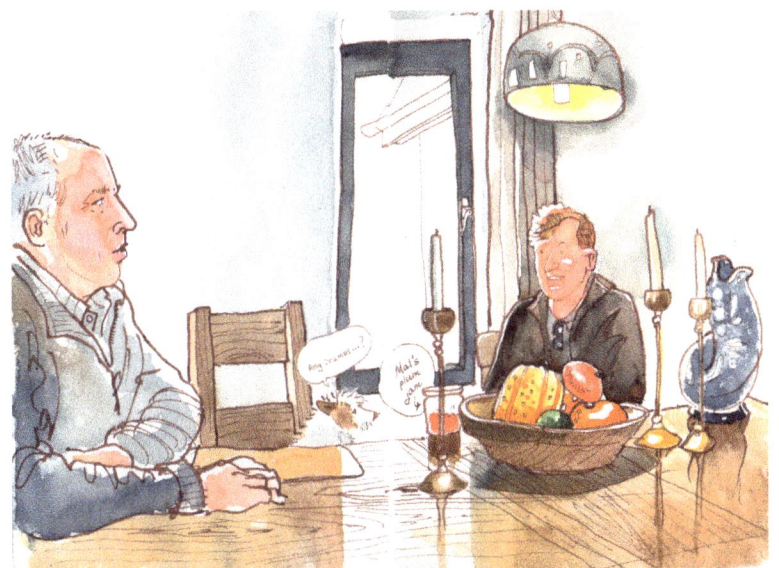

🎧 Some family members are storytellers. Take the opportunity to capture them in mid-flow—and their audience, who will listen politely.

Mal Tells a Story
A5 (5¾" x 8¼" | 14.8 x 21 cm) Hahnemühle sketchbook (double spread), fude pen, ink, and watercolor.

Friends and Colleagues

When drawing friends or other sketchers, you are ahead of the curve. Your friends will be too polite to fidget or criticize (much). Your fellow sketchers get what you're trying to do and will keep still for ages. They'll even take the pose again if you ask them.

> **Tip**
>
> Don't ask your friends if they mind being sketched: Just do it. Ask for forgiveness (if necessary), not permission.

◑ Look for seemingly small details: They make a big difference. The direction the wind is blowing. The direction of light. Use a fine nib to scribble out the shapes until you feel more confident.

Sketchers in Haarlem, The Netherlands
A5 (5¾" x 8¼" | 14.8 x 21 cm)
Hahnemühle watercolor sketchbook, fude pen, ink, and watercolor.

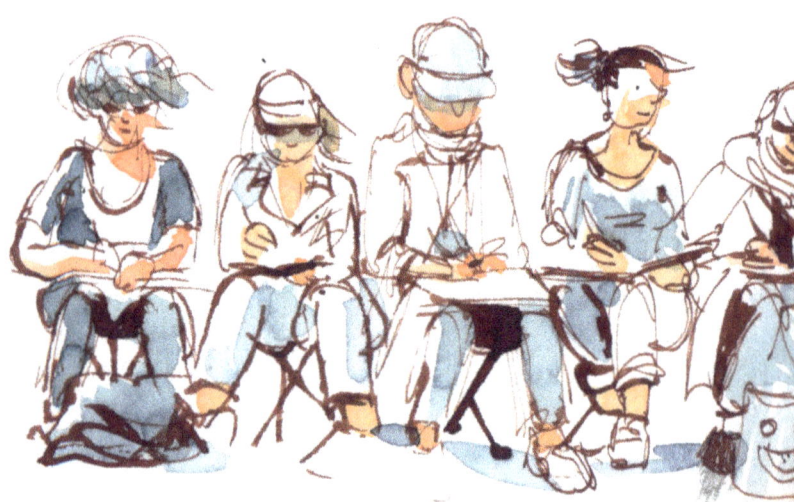

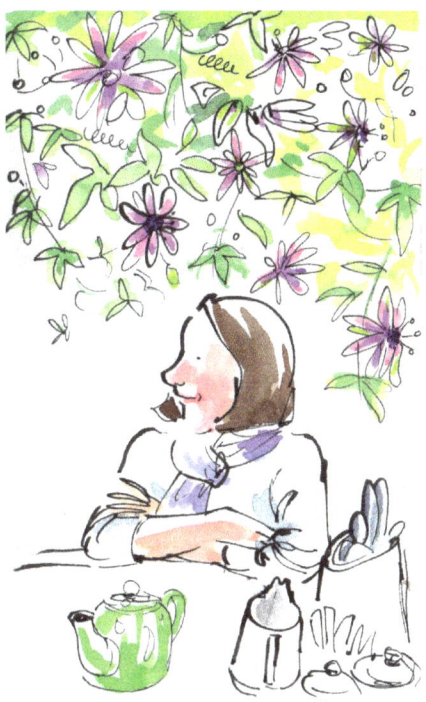

◐ Take a minute to sketch your friends when you go for a cuppa together or a convivial meal in a restaurant. Even the barest suggestion of shapes and lines will go a long way.

Tea Under Passion Flowers
A5 (5¾" x 8¼" | 14.8 x 21 cm)
Fabriano Venezia sketchbook, fude pen, ink, and watercolor.

All artwork on this spread:
RÓISÍN CURÉ

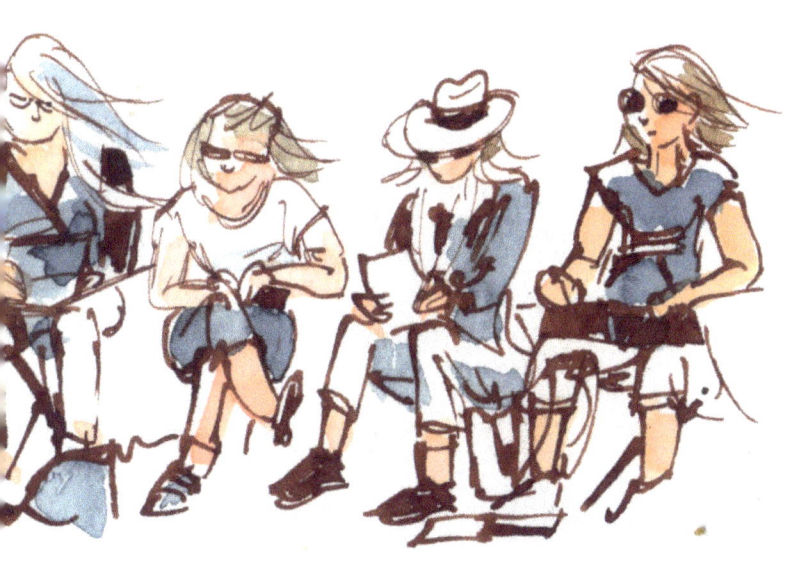

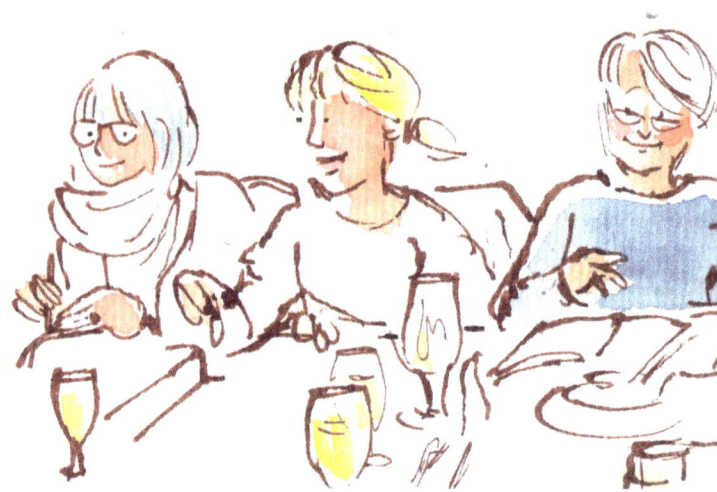

All artwork on this spread:
RÓISÍN CURÉ

◑ A quiet moment in an English pub was just long enough to capture a group of sketchers.

The Six Bells, Woodchurch
A6 (4⅛" x 5¹³⁄₁₆" | 10.5 x 14.8 cm)
Hahnemühle watercolor sketchbook, fude pen, ink, and watercolor.

➲ Keeping the color palette limited to just two or three dominant colors helps to ensure harmony throughout the sketch.

USk Galway Meeting
A5 (5¾" x 8¼" | 14.8 x 21 cm)
Hahnemühle watercolor sketchbook, fude pen, ink, and watercolor.

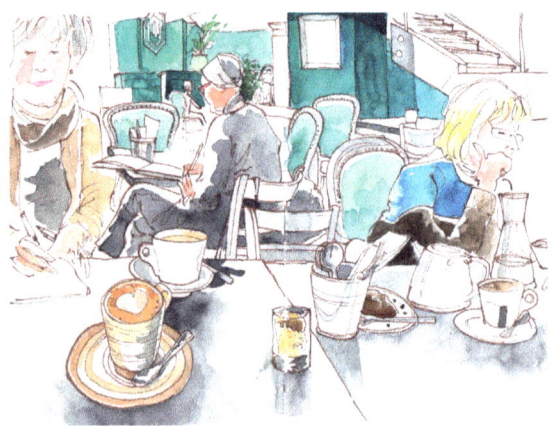

Key II: Challenges | **39**

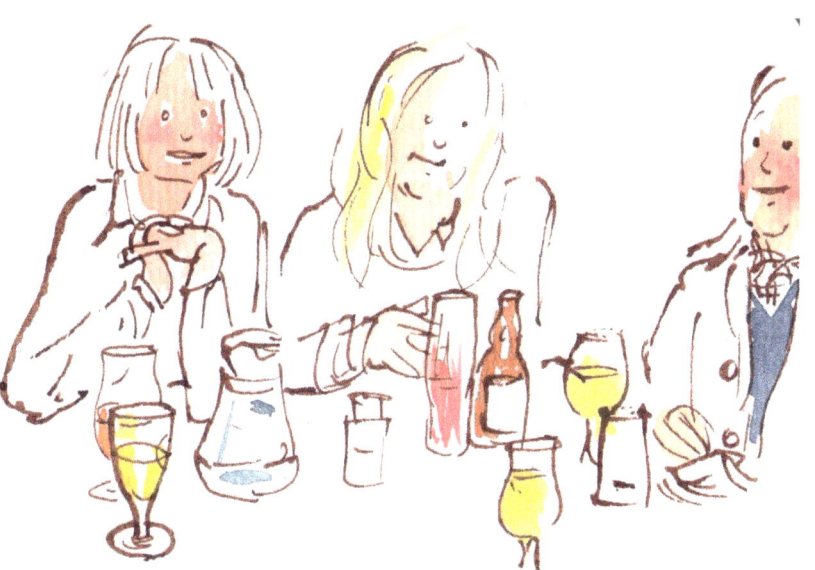

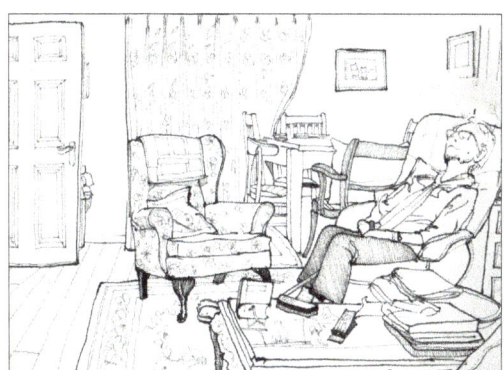

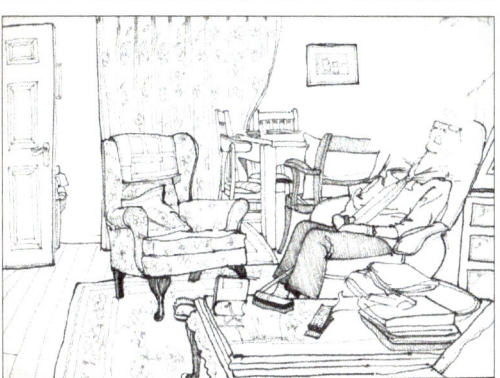

◐ You might feel intrusive if you're sketching someone in a vulnerable position, such as this image of my mother-in-law having a nap, with her head back. I felt I shouldn't leave it like that, so I tore a piece of paper from the back of my sketchbook and taped a flap on top. But my mother-in-law has a great sense of humor and found it very funny—and gave me a beautiful memory in the process. My advice is just to sketch and worry about the consequences later.

Catching Flies
A4 (8¼" x 11½" | 21 x 29.7 cm) watercolor sketchbook, carbon pen, and ink.

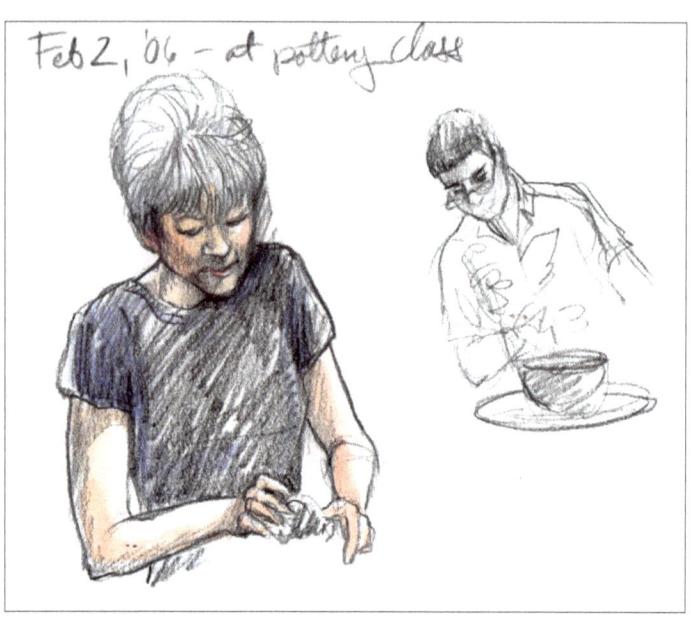

"I loved the woman's pose and the concentration on her work."
—Cathy Johnson

◯ CATHY JOHNSON
Pottery Class
8" x 8" | 20.3 x 20.3 cm;
wax-based colored pencil with
light wash.

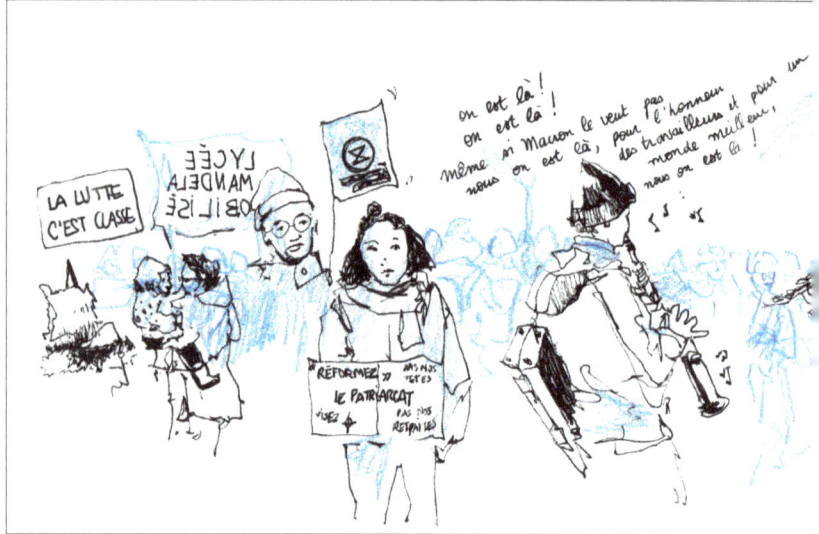

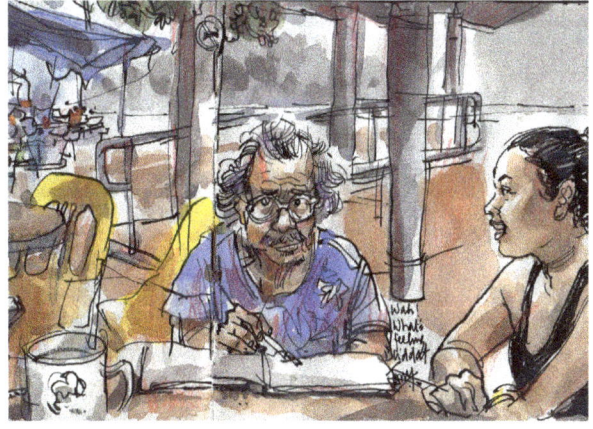

☾ DON LOW
Coffee with Tony
8½" x 5⅞" | 21.5 x 15 cm; fountain pen, watercolor wash, and colored pencil on sketchbook.

"If time permits, I usually add watercolor over my ink drawing, which is usually done in fountain pen and waterproof ink that won't bleed or dissolve. To break the monotony of the wash, I add rough colored pencil strokes, perhaps to add color accents. I love to capture the expression and unique gestures of my subject." –Don Low

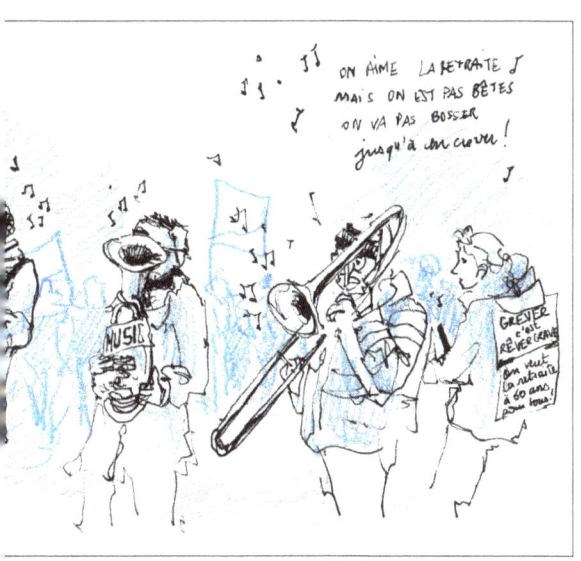

☾ Using a contrasting, softer color to suggest a crowd in the background is a tried and tested technique. Detail in foreground figures can stand out without being swamped by the crowd.

CHARLINE MOREAU
Musicians Protesting Against Pension Reform
16½" x 5⅞" | 42 x 15 cm; watercolor, watercolor pencils, and brush pen.

SKETCH HERE!

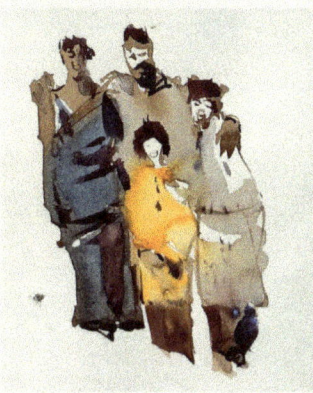

KEY III
PROPORTIONS

As a sketcher, you could be forgiven for thinking that drawing expressive people is all about the face. But an expression is worn on the body as much as on the face. Shoulders slump or are high and tense. Heads are held high or tilted quizzically. Body language tells you much about what a person is feeling.

Practice, from life, makes perfect. Photos don't give you the necessary three-dimensionality you need nor the pressure that will force you to cut to the chase.

While my counsel is always to draw what you see, sometimes a little pre-acquired knowledge about proportions and relative sizes of parts of the body can come in handy.

◯ UMA KELKAR
Captain Haddock, aka Husband, Dressed Up
10" x 4" | 25.4 x 10.2 cm; watercolor.

Bodies

Think of the spine as a flexible articulated rod—which is exactly what it is. All body positions depend on what the spine is doing.

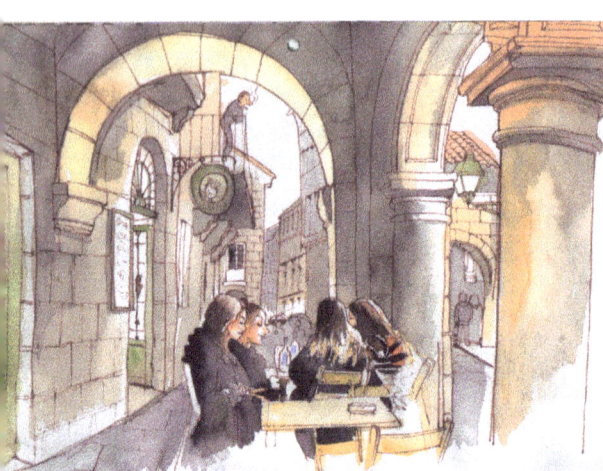

◐ Draw people from behind. These girls were lost in their own world. Even though I was the only other person outside that café and at the next table, no one noticed my presence at all.

Girls in Santiago de Compostela

A3 (11¹¹⁄₁₆" x 16½" | 29.7 x 42 cm) Hahnemühle 300g watercolor block, fude pen, ink, and watercolor.

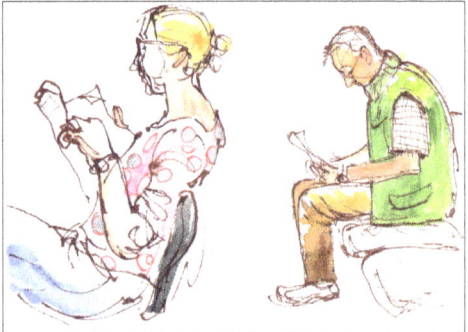

◐ These two sketches of people reading a newspaper show very different positions, both with the spine as the anchor of the pose. Shoulders usually start just below the ears when a person is seated, as we tend to slouch a bit when we lean forward. We hunch our shoulders even more when we are tense.

Waiting

A6 (4⅛" x 5¹³⁄₁₆" | 10.5 x 14.8 cm) Hahnemühle sketchbook, fude pen, ink, and watercolor.

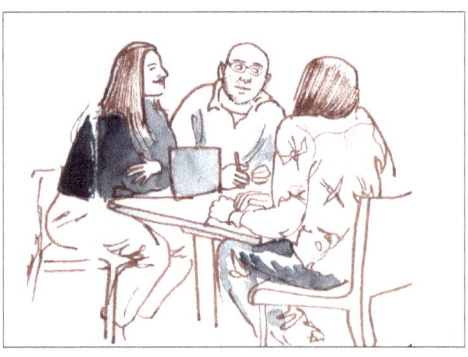

◐ It appeared that this young woman was being interviewed, and the tension in her shoulders said it all.

Interview

A5 (5¾" x 8¼" | 14.8 x 21 cm) Hahnemühle watercolor paper, fude pen, and ink.

All artwork on this spread:
RÓISÍN CURÉ

ACCURACY

There are lots of resources available to learn about proportions, including books on everything from classical drawing to cartooning, which will all tell you how many "heads high" a figure is. Read those books and glean what you can from them—it's all good to know—but eventually it's just going to be you and your fidgety subject. No books. Just observation.

Draw what's there, not what you *wish* or *think* or *know* to be there.
1. Start with the head.
2. Put in the shoulders and the neckline and start each arm.
3. Put in the rest of the body.

↻ I like to honor my subjects (and the drawing) with the truth (although, if my subject asks me to "improve" a feature they don't like, I try to oblige).

A Break from the Betting Shop
A6 (4⅛" x 5¹³⁄₁₆" | 10.5 x 14.8 cm) Hahnemühle watercolor sketchbook, fude pen, ink, and watercolor.

It can be a bit daunting to draw directly in ink. Many say it will do wonderful things for your voice and your confidence, but there can still be that familiar stage-fright feeling. A good halfway point is to sketch your subject lightly, then trace over the lines in a bolder or darker nib when you have found your confidence.

↻ You won't notice the "wrong" lines once you've painted everything.

Tip

If you find even the thinnest pen nibs too daunting, use a nearly spent fine pen to sketch your lines. It has the subtlety and sketchiness of a pencil with the indelibility of pen.

Another aspect of the failings in the "how many heads high" method is that you will often be unable to see the entire body in order to see and count all those heads. Your subjects are very likely to be doing a good job of hiding their whole body. So, go ahead and use the "how many heads" system, but in a slightly different way: Apply it to the portion of the body as you see it.

- How many heads fit?
- How many heads wide are the shoulders?
- How many heads long is the back?
- How many heads would fit into the space between the subject's chin and the table?

Tip

Dart your eyes rapidly between your subject and your sketch. The differences will be quickly apparent.

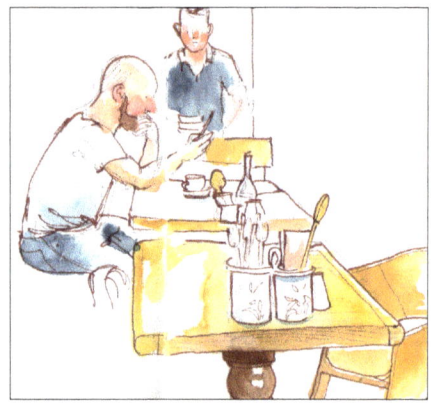

Here's a good candidate for using a head as a unit of measurement.

Pick a strong shape—it could be anything, but a head works—and compare its size to everything you are trying to draw. This simple key to drawing accurately can be used for everything from buildings (use a window as your unit) to landscape (use a tree) to, of course, people. It is easy, fast, and doesn't require peering through a square or at a pencil or a thumb. This method is part of the very essence of getting the correct proportions.

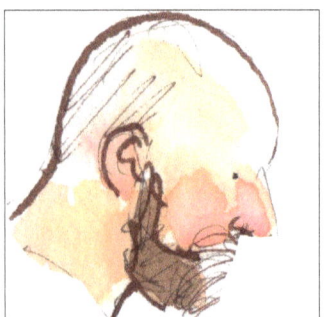

And here's the unit of measurement itself.

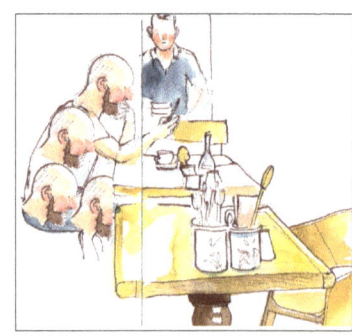

Observation is the key to making a beautiful drawing. I can name incredible artists who observe nothing but the caprice in their mind, but that cannot be taught. What *can* be taught is how to draw correctly. This leads to confidence, which leads to fluency, which leads to artistry. In time, and with practice, your mind will make an instant judgment as to the correct proportions, and you will do it unconsciously.

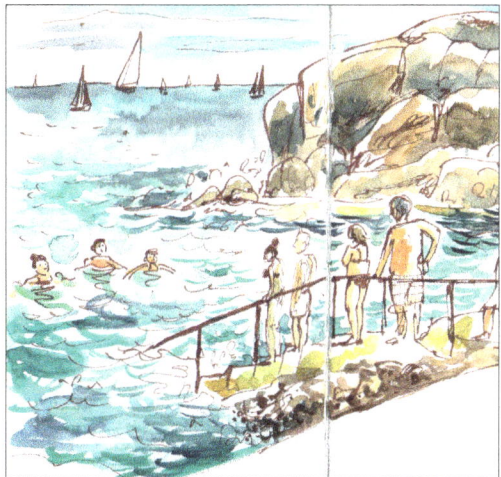

◔ These swimmers were dawdling, unwilling to jump into the cold sea—a perfect opportunity to capture life drawing-style subjects.

RÓISÍN CURÉ
Forty Foot, Dublin
A5 (5¾" x 8¼" | 14.8 x 21 cm) Hahnemühle watercolor sketchbook, fude pen, ink, and watercolor.

Tip

Go where people swim, and you'll find full bodies you can see from head to toe.

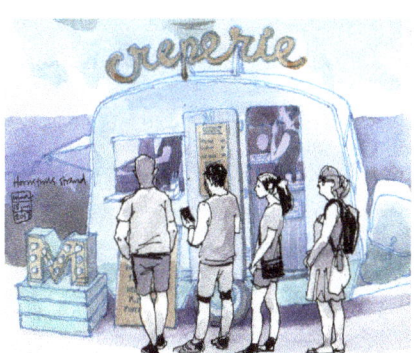

◔ **NINA JOHANSSON**
Queue at the Creperie
7½" x 5⁹⁄₁₀" | 19 x 15 cm; fountain pen with black and blue ink, and watercolor.

"The crepes caravan is sometimes part of the Stockholm street markets at the walkway by the water. Since crepes take a while to make, the people in the queue were fun to draw and stood reasonably still for just long enough to draw them."
—Nina Johansson

PROPORTIONS
Face and Head

For a very small part of the body, the face exhibits a disproportionate amount of action, and the shape of the head is a big part of what makes someone distinctive. But, luckily for the sketch artist, most of the facial features remain fixed.

Position of the Features and Head Shapes

- The eyes are halfway down the head, from the top of the head to the bottom of the chin.
- The nose is level with the ears.
- Only the lower jaw moves.
- When the head tilts, everything does.
- Gravity makes any fatty bits fall forward.
- Heads stick out at the back, even the ones that look flatter.
- The bulge goes in at the neck in slimmer people.
- Eyes are in line with the top of the bridge of the nose.

While every face has many things in common, look for what makes them different . . .

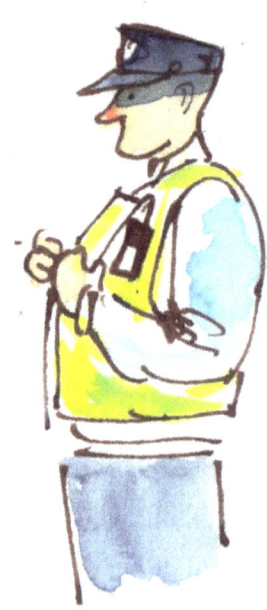

◯ Look for a pointy nose and delicate coloring.

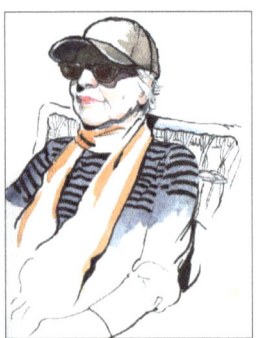

◯ Capture the delicacy of wrinkles.

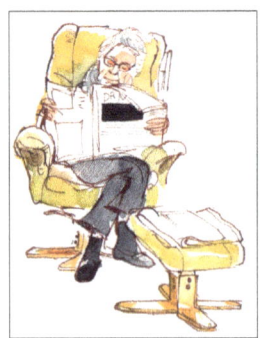

◯ Watch how the jowls fall forward in the elderly.

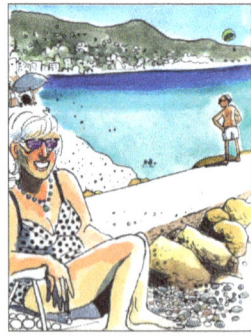

◯ You don't need to show lines between teeth.

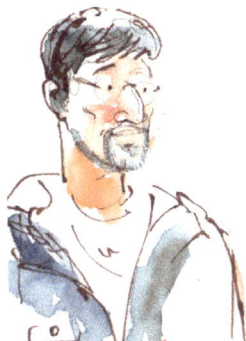

◔ The fatty jowls fall forward in the young too, if they are leaning forward a long way.

All artwork on this spread:
RÓISÍN CURÉ

◔ Use the very thin nib for those delicate features such as sharp cheekbones.

Mouths

- Look for lines around the edges.
- Look for fine lines around the lips.
- Full lips or thin lips?
- Pronounced underbite or overbite?
- Strongly colored lips?
- Look for that shadow under the bottom lip that disappears in a smile.

Eyes

- I draw eyes as dots, but you'll find your own way.
- Look for bags under the eyes, but don't overemphasize them.
- Are the eyes expressing surprise or animation? Use the eyebrows to tell the viewer.
- Eyelashes: a heavy line? Or a fine line?
- Only draw lines you see. Don't revert to a childlike memory of how you drew eyes (even though we probably all retain a little of that).

Noses

- The nose is level with the ears.
- Look for strong shapes: bulbous noses, Roman noses, turned-up noses, pointy noses.
- Look for that little shadow under the nose.
- Don't forget the nostrils.

Jaws and Chins

- Look for jowls around the jawline.
- With a sagging chin, the line of the chin is not well defined.
- Look for a double chin.

Eyebrows

Eyebrows are a godsend as a way to show what your subject is feeling.

Adults and Seniors vs. Children

Pay attention to general differences between younger and older subjects.

OLDER	YOUNGER
Lines are more pronounced	Lines are less pronounced
Eyes are higher in the face	Eyes are relatively lower and wider apart
Mouth sinks with respect to the chin	Mouth and lips protrude and are more fleshy
Jowls hang	Cheeks are full
Hair is wispier	Hair may be glossy or thick
Nose may be beaky, fleshy, or larger	Nose may be turned up or delicate
Bags under the eyes	No bags under the eyes
Flesh of the neck may start at the base of the chin	Well-defined jawline

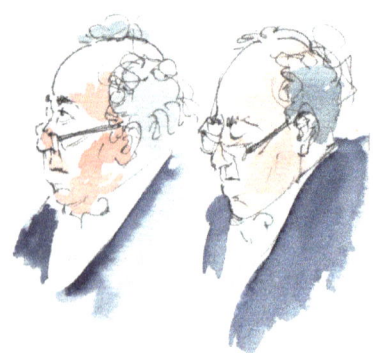

The jowls and fleshiness of old age are delicately depicted in a thin nib.

The mouth and lips become stretched in a thinner face and take on a concave form.

Key III: Proportions | **51**

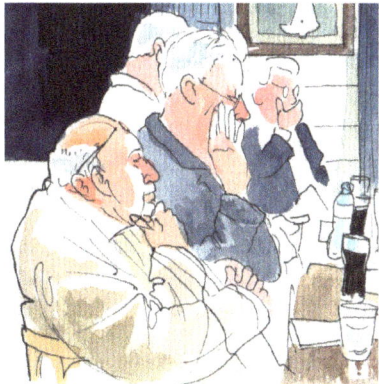

❶ The large, prominent nose of an old man . . .

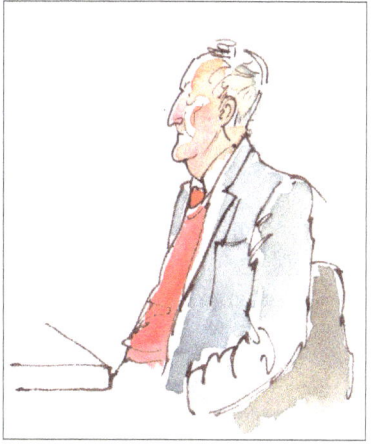

❶ . . . and the beautifully defined features in a profile that has seen many seasons.

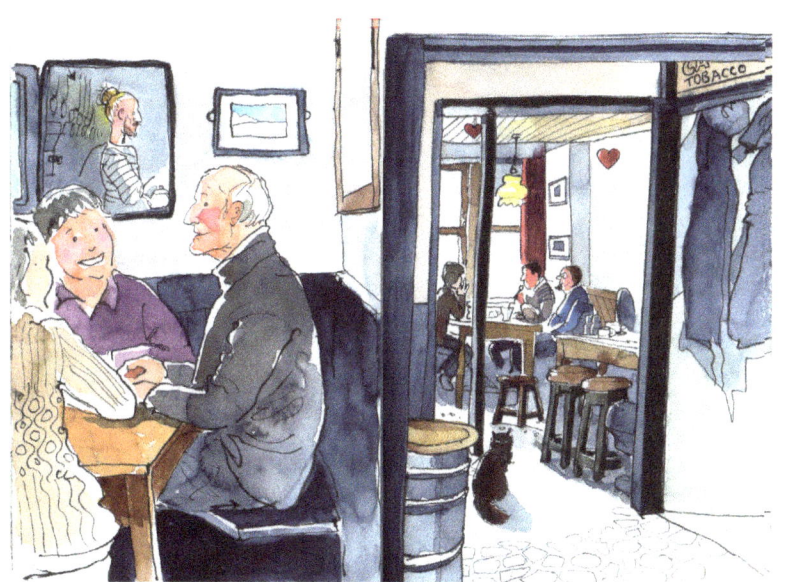

❶ Elderly people do not move fast, which may make them less challenging to draw.

Tip

When drawing a face, squint and look for shadows and only draw lines that have shadows.

52 | Drawing Expressive People

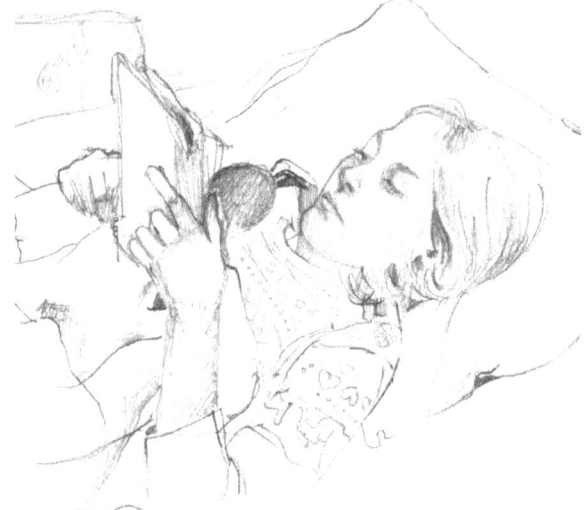

➲ The lack of lines means a child's face must be drawn with great sensitivity.

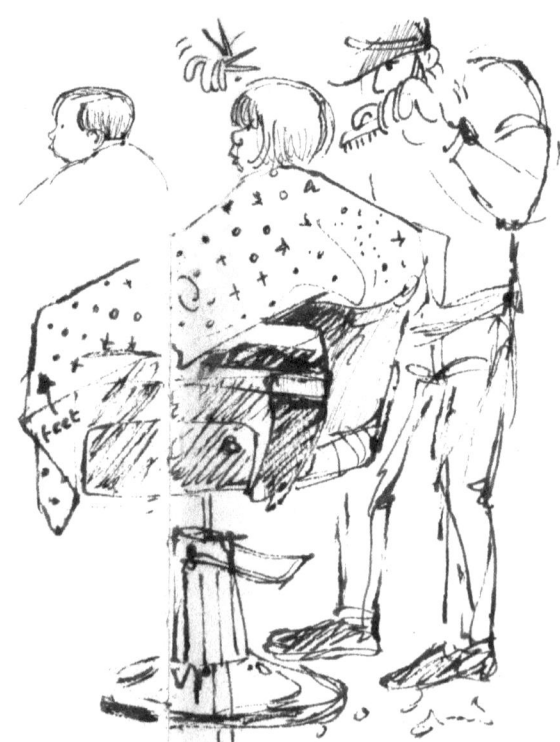

➲ This toddler's face was all about plump cheeks and a protruding mouth.

Key III: Proportions | **53**

❶ These children are drawn with the minimum of lines: Notice how far apart and how innocent the eyes appear.

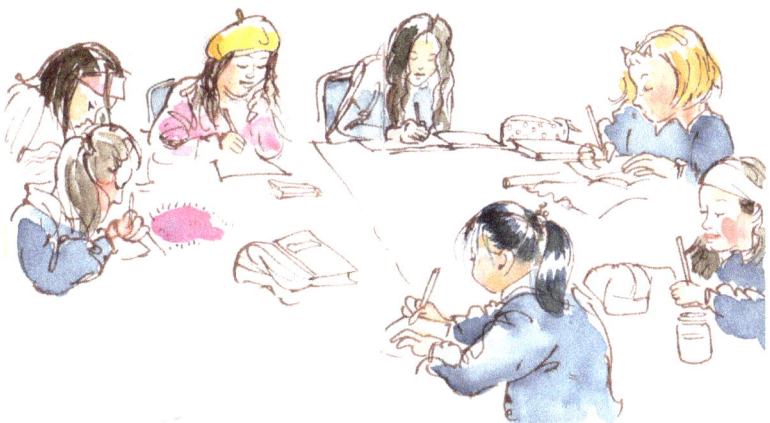

❶ These children all have glossy hair and plump cheeks.

Hands and Feet

"I can't draw hands!"

Is this something you've heard? Or said?

I can draw hands, but I cannot draw feet. They are my Achilles' heel, so to speak. So I understand. You can get away with rudimentary feet, but hands are an important part of the expressivity of a figure. You need to draw hands, even if they're little more than a bunch of bananas.

Here are some facts about fingers and hands:
- The middle finger is the longest and, correspondingly, the knuckles are a little further along the finger.
- The thumb points in a different direction and curves outward.
- Knuckles all line up when the hand is bent.
- Shadows fall differently on the two or three planes of a closed hand.

Hands

Tip

Use your own hands to figure out where the thumbs go.

All artwork on this spread:
RÓISÍN CURÉ

⊃ You can get away with the merest suggestion of fingers. The action will make it clear.

Gallery Café
5⅞" x 7⅞" | 15 x 20 cm
Hahnemühle watercolor sketchbook, fude pen, ink, and watercolor.

⊃ You'll be drawing many hands fiddling with phones. In addition to fingers, consider the planes of the hands and develop a "shorthand"— literally—to draw them.

A Norwegian in Galway
A4 (8¼" x 11½" | 21 x 29.7 cm) Hahnemühle watercolor sketchbook, fude pen, ink, and watercolor.

Key III: Proportions | **55**

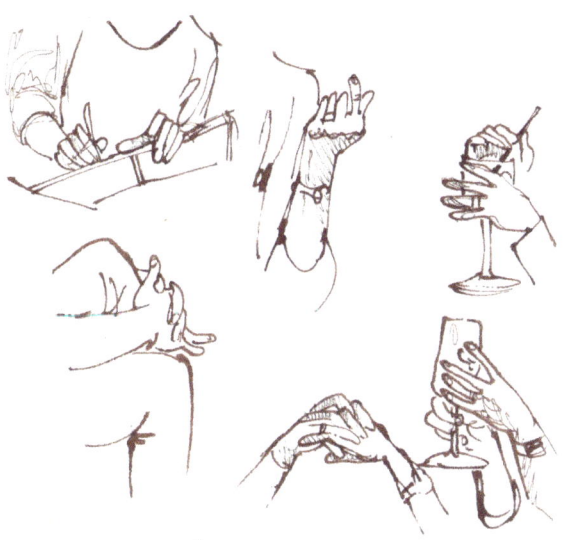

◐ Hands tell you so much more than about the task they're doing. We talk with our hands.

Women of Haarlem

A5 (5¾" x 8¼" | 14.8 x 21 cm) Hahnemühle watercolor sketchbook, fude pen, and ink.

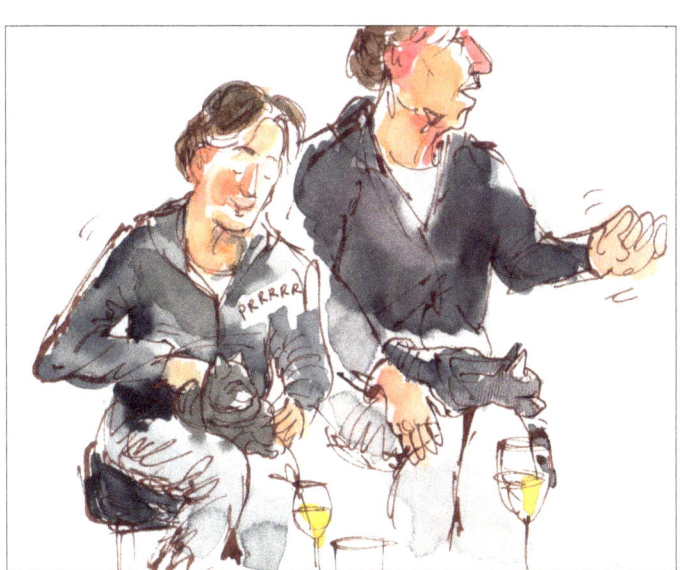

◐ Sometimes it's all about the hands. It's your sketch—draw it as many times as you like. The expertise isn't what matters; it's important just to do a basic hand shape.

Sparkle

A4 (8¼" x 11½" | 21 x 29.7 cm) Hahnemühle watercolor sketchbook, fude pen, ink, and watercolor.

Feet

Feet rarely contribute a huge amount to expressivity—mainly just when they aren't shod. So, you can get away with bricks-with-points for feet. However, well-observed feet are delicate and beautiful.

➲ Bare feet out of context can make a lovely subject.

Argentinian Busker, Galway (detail)

5⁷⁄₈" x 4¹¹⁄₁₆" | 15 x 12 cm
Hahnemühle 200g watercolor sketchbook, fude pen, ink, and watercolor.

➲ *Santiago Airport* (detail)

4¹¹⁄₁₆" x 5⁷⁄₈" | 12 x 15 cm
Hahnemühle watercolor sketchbook, fude pen, ink, and watercolor.

All artwork on this spread:
RÓISÍN CURÉ

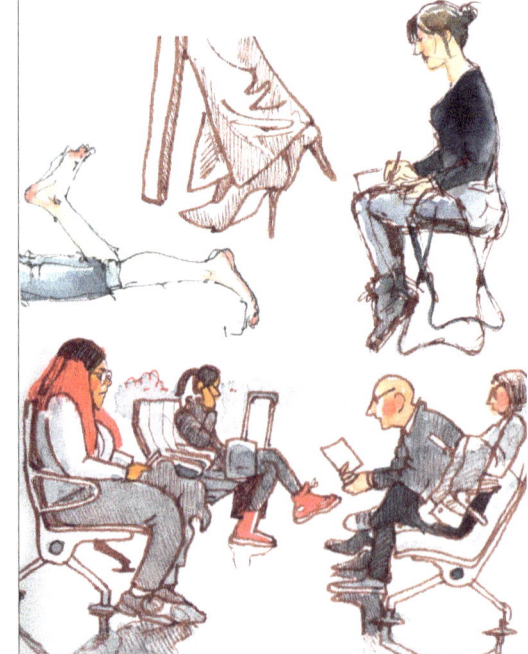

Feet Facts

- The far (back) foot is slightly higher than the nearer foot, which makes them look planted apart. The back foot is slightly higher than the front foot, even when there is a distance between them, such as when the figure is walking.
- The big toe turns up, and the other toes turn down and slope away from the big toe.
- Shoes nearly always have a substantial sole and a heel, which are a big part of the foot.

↻ Practice sketching feet in various footwear, from flip-flops and sandals to heels and boots.

Mulroog Shore

A5 (5¾" x 8¼" | 14.8 x 21 cm) *Fabriano Venezia sketchbook, fude pen, ink, and watercolor.*

⊃ **JOHN SHORT**
Market Bag Seller, Beijing
8½" x 11½" | 21 x 30 cm; watercolor, ink, Chinese stamps, and collage.

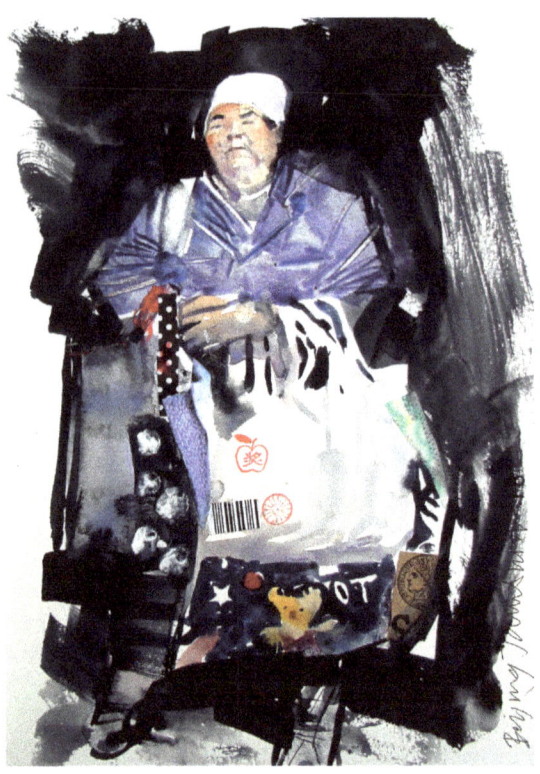

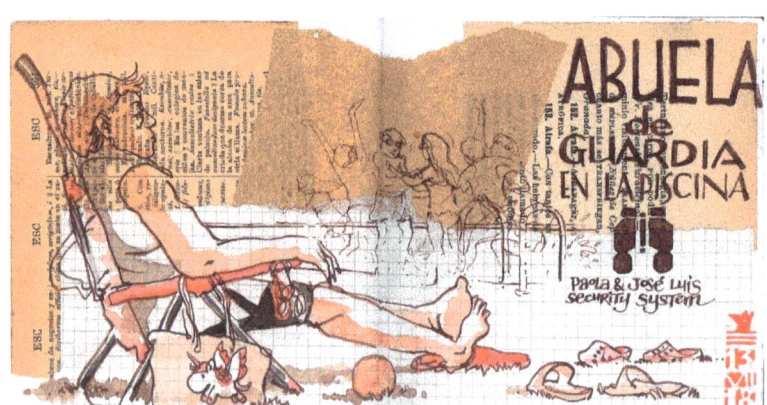

🎧 Alfredo Ugarte—better known as URUMO—manages to combine the discipline of excellent observation with the playfulness and invention of collage.

URUMO
Guard Grandmother of the Swimming Pool
10⅜" x 5⁵⁄₁₆" | 26.5 x 13.5 cm; collage of old papers, fude pen, brown ink, and watercolor.

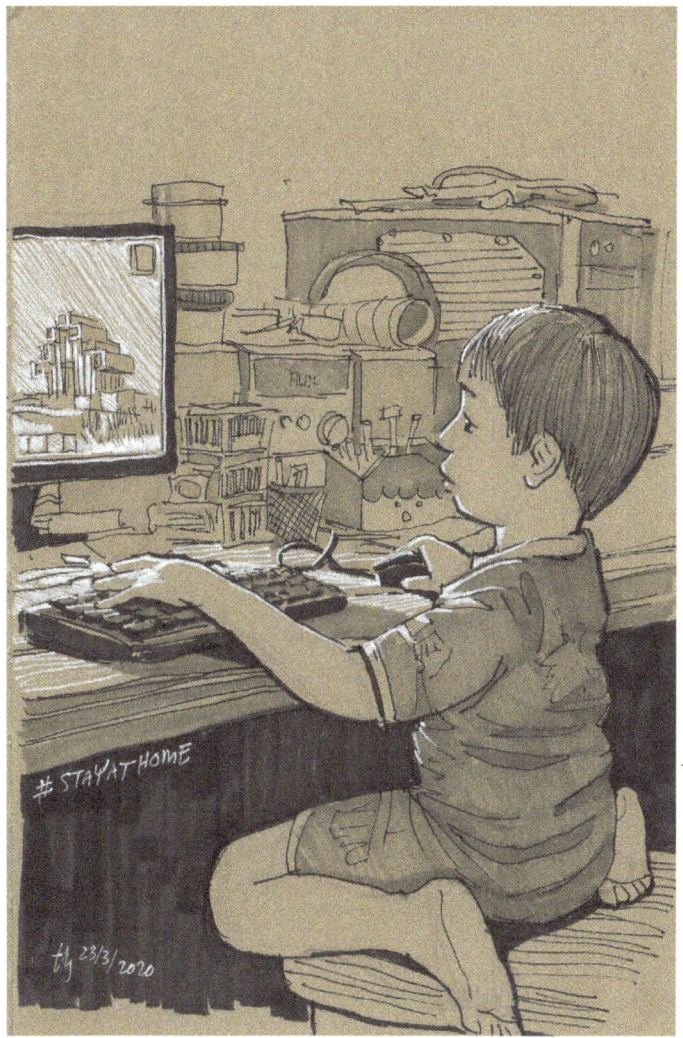

◯ THOMAS HARRY GUNAWAN

Playing a Game
A5 (5¾" x 8¼" | 14.8 x 21 cm) Kraft sketchbook, markers, and white gel pen.

"I sketched my son while he played Minecraft at home, during his first week of 'school from home' during quarantine."
—Thomas Harry Gunawan

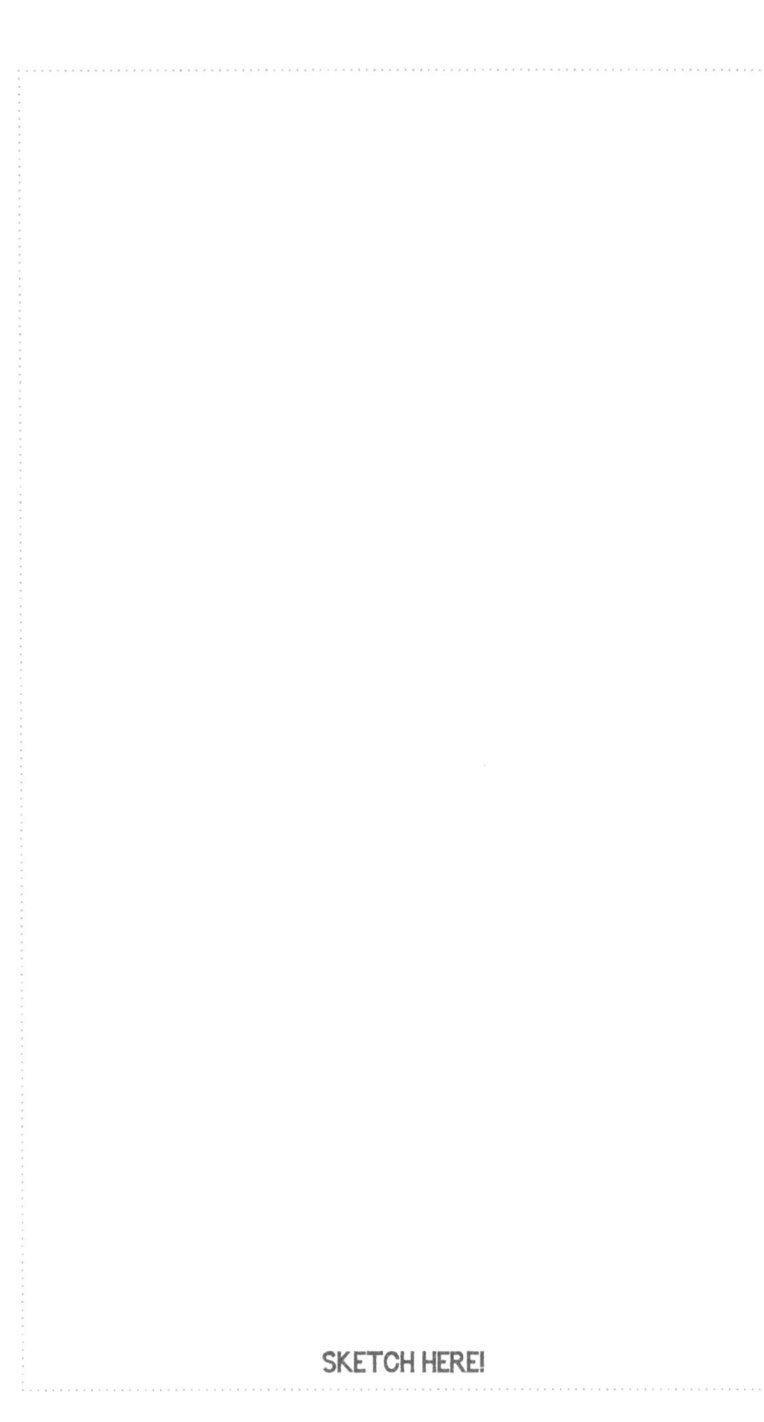

SKETCH HERE!

KEY IV
POSES & ACTIONS

Getting your poses right comes back to the same thing: good observation. Learn to look honestly, see, and then draw correctly and you can push your poses in whatever direction your heart tells you to. Drawing correctly is a skill. It's up to you to put your own creative stamp on your work, while still retaining the essence of the pose.

⌒ RÓISÍN CURÉ
Dorothy the Barber
A5 (5¾" x 8¼" | 14.8 x 21 cm),
carbon pen, grey ink,
and watercolor

COMMON POSES

The number of poses you will encounter on your urban sketching outings is large—perhaps infinite. But there are many poses you will encounter again and again. After a while, you'll know exactly what the task requires, and it will get even easier.

> **Tip**
>
> Forgetting what you *know* the arrangement of the features of the face to be, or the pose, and drawing just what you see, is crucial, but easier said than done. Imagine you're an alien who has never seen a face before or even knows that such a thing as three dimensions exists and you have to describe a human in a sketch for your commander. Think information.
>
>
>
> ↑ Channel your inner alien.

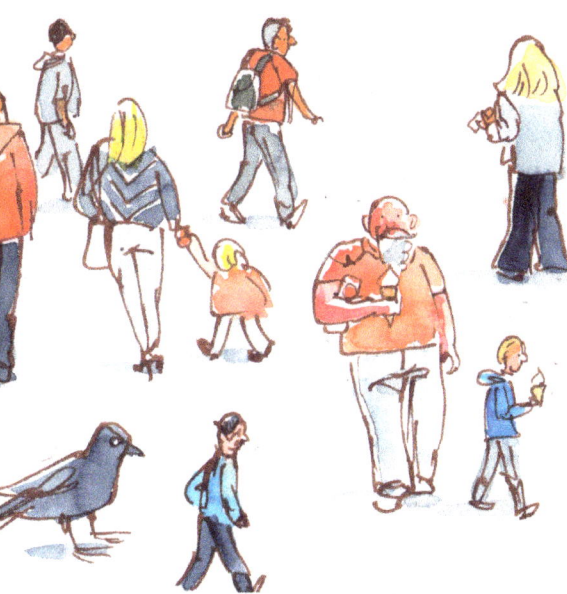

◐ A great way to practice is to join in one of those online challenges where you might increase the number of poses you draw in a week.

RÓISÍN CURÉ
One Week, One Hundred People
A5 (5¾" x 8¼" | 14.8 x 21 cm) (double spread); fude pen, ink, and watercolor.

Walking

Take a "sight reading" of where your subject's head is in relation to the environment: Look where the head is in relation to a window or a mark on a wall and look at where their feet are. Then continue to draw your figure between the two points.

Places to Capture Lots of People Moving

- At the entrance to a busy shop, office, or hospital
- Beside a street with heavy pedestrian traffic
- At a sporting event
- At a children's get-together
- Even if you are at home, you can still watch people—on YouTube! Try sketching from a dance video, for example, and you have the luxury of hitting the pause button if you need to.

Tips

- Ever notice that people may have their hands in their pockets when they walk at an easy stroll, but move their arms when they step up the pace?
- Though people aren't all the same height, their heights don't differ a huge amount in comparison to all the things you might like to include in your sketch.

Shifting Weight

Quentin Blake is a British illustrator whose figures are deceptively simple. They might look playful, but they're always believable. During a documentary, he passed on a useful tip: Ask yourself which leg is holding the weight.

You'll notice that weight shifts from leg to leg. Draw fast—then wait for the pose to be taken again. Imagine a vertical line extending from the head through the spine and down to the feet: That's the line of weight.

All artwork on this spread:
RÓISÍN CURÉ

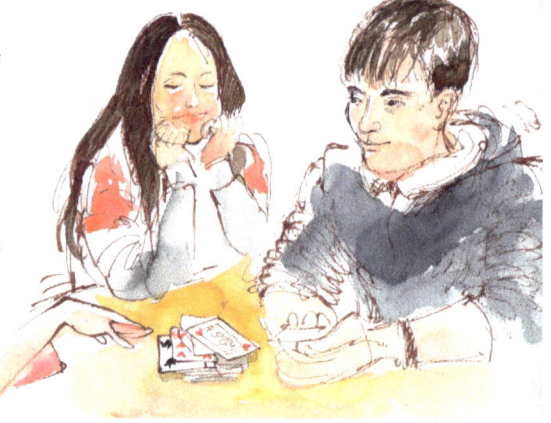

➲ Look at the weight on the hands and arms . . .

Sophia

A4 (8¼" x 11½" | 21 x 29.7 cm) Hahnemühle watercolor sketchbook, fude pen, and watercolor.

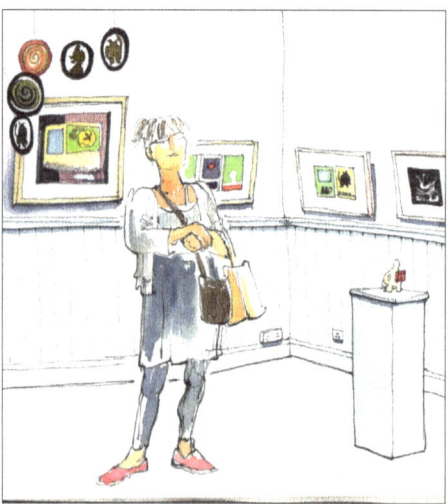

☛ . . . and on the legs.

Julia

A4 (8¼" x 11½" | 21 x 29.7 cm) AMI watercolor sketchbook, carbon pen, ink, and watercolor.

Tip

People walking straight past you are there for only an instant. Illustrate a receding or an approaching figure and you'll get more time.

Sitting

The point at which the body and the support meet (e.g., a chair) requires careful observation. Catch that vertical line of weight, which continues through the legs of the chair.

❶ Capture an artist friend at work; they won't even notice you and they'll keep still.

Federico

A5 (5¾" x 8¼" | 14.8 x 21 cm) Hahnemühle watercolor sketchbook, fude pen, and watercolor.

❶ A bag is a big part of the weight of your subject. Allow the bag to be a counterbalance to your figure's lean.

Ciara

3⅞" x 3⅛" | 10 x 8 cm Fabriano Venezia sketchbook, fude pen, and watercolor.

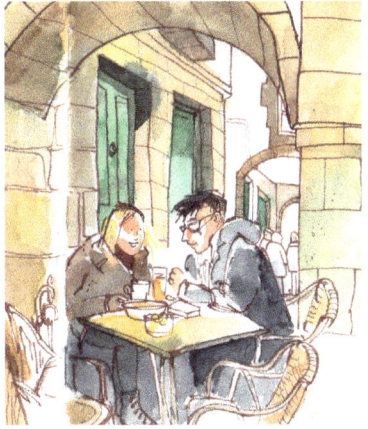

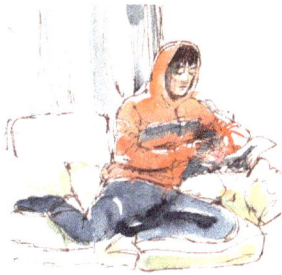

❶ Look for shoulders hunched against the cold.

Bar in Santiago de Compostela in November

A5 (5¾" x 8¼" | 14.8 x 21 cm) Hahnemühle watercolor sketchbook (double spread), fude pen, and watercolor.

❶ The more unusual the pose, the better: You'll be less likely to have preconceived ideas of what you're drawing. Therefore, you'll be less likely to think you know what's there before you start looking properly!

Paddy

A5 (5¾" x 8¼" | 14.8 x 21 cm) Hahnemühle sketchbook, fude pen, and watercolor.

BODY LANGUAGE

A quick sketch of a human is the equivalent of an overheard snatch of conversation. What does the body say?

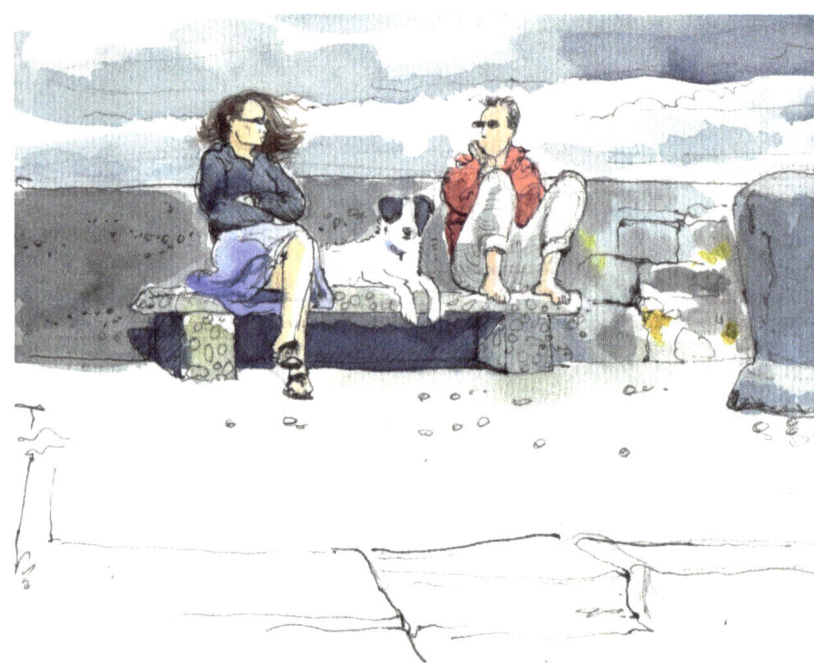

🎧 These two women studiously ignored the fact that I was drawing them, but the dog's body language spoke volumes; it was on high alert. Animals make it easy to read their body language, and humans do, too, most of the time. Look for shoulders hunched in tension, arms crossed protectively, or a head held defiantly. And practice. A quick line drawing is all you need to make a subtle and expressive drawing.

All artwork on this spread: **RÓISÍN CURÉ**

Killeenaran Pier
A5 (5¾" x 8¼" | 14.8 x 21 cm)
AMI watercolor sketchbook, carbon pen, ink, and watercolor.

➲ Look how the weight of the floppy toddler has thrown the mother backward.

Waiting for the School Bus
6¹¹⁄₁₆" x 4¹¹⁄₁₆" | 17 x 12 cm
AMI watercolor sketchbook,
carbon pen and ink.

⊃ Look for someone's idiosyncratic pose, such as chewing glasses.

In Thought
4¹¹⁄₁₆" x 4¹¹⁄₁₆" | 12 x 12 cm AMI watercolor sketchbook, Noodler's fountain pen, non-waterproof ink, and watercolor.

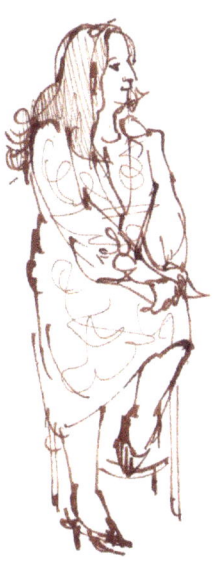

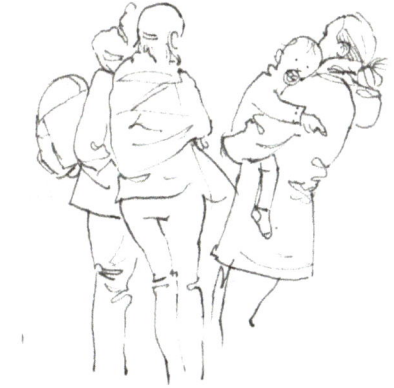

◐ The clear depiction of weight makes all the difference to this simple drawing.

Women's Network Evening
4¹¹⁄₁₆" x 3³⁄₁₆" | 12 cm x 8 cm Hahnemühle watercolor sketchbook fude pen and ink.

OTHER POSES

↺ **Lying down.** The weight is distributed differently when a body is reclining, and in some ways it is easier to draw, as the person is likely to be comfortable for a while.

Paddy on the Sofa
A5 (5¾" x 8¼" | 14.8 x 21 cm) AMI watercolor sketchbook, carbon pen, ink, and watercolor.

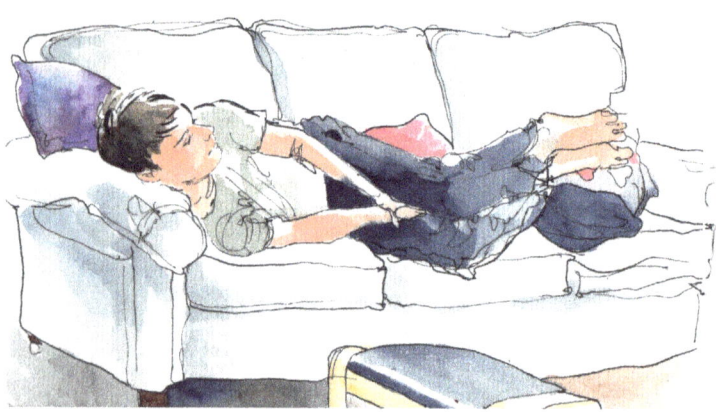

⊃ **Clapping.** People clapping aren't focusing on you. If you feel the person getting the applause can do with one fewer person clapping, sketch the others!

Sports Awards Night
A6 (4⅛" x 5¹³⁄₁₆" | 10.5 x 14.8 cm) Hahnemühle watercolor book (double spread), fude pen, ink, and watercolor.

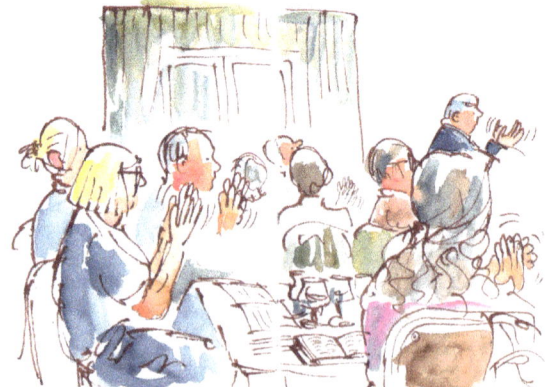

All artwork on this spread: **RÓISÍN CURÉ**

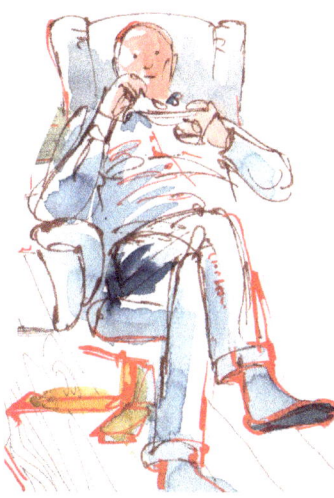

◐ **Eating.** Look for an unusual pose when someone is tucking into food.

Plum Pudding (detail)

A5 (5¾" x 8¼" | 14.8 x 21 cm) Hahnemühle watercolor sketchbook, fude pen, ink, and watercolor.

◒ **Animals.** Animals, especially if they are a major part of the scene, can add considerably to the context of a human scene.

Caroline in the Algarve

A5 (5¾" x 8¼" | 14.8 x 21 cm) Hahnemühle watercolor sketchbook, fude pen, ink, and watercolor.

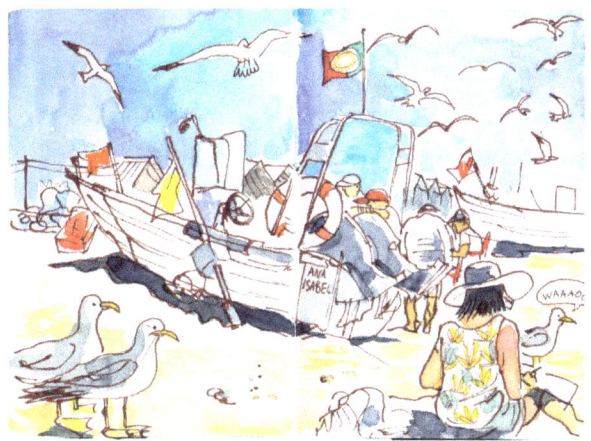

◐ **Direction.** If you draw the direction a person is looking, there is a story there.

John Quinn Recites

A4 (8¼" x 11½" | 21 x 29.7 cm) AMI sketchbook, carbon pen, ink, and watercolor.

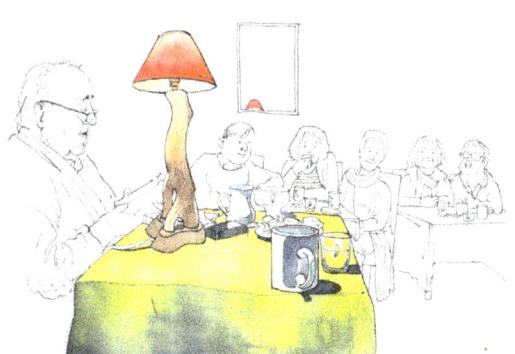

⊃ No one exists but the other in this charming sketch, where perfectly observed shapes allow the expressions to do all the talking.

NICOLA MAIER-REIMER
He Adores Her

A5 (5¾" x 8¼" | 14.8 x 21 cm) Hahnemühle watercolor book, pencil, and watercolor.

RITA SABLER
Isabelle During Quarantine

16" x 7" | 40.6 x 17.8 cm fragment of an accordion book, ink, pencil, and watercolor.

↺ These beautiful images of the artist's daughter during the coronavirus quarantine will be a truly special memory in the years to come.

Key IV: Poses & Actions | 71

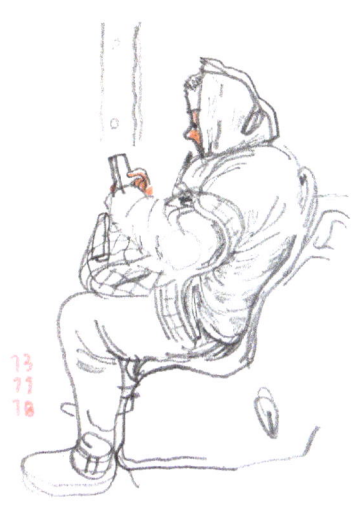

☾ SEBASTIAN KOCH
Young Guy on the Bus
5¹¹⁄₁₆" x 8⁵⁄₁₆" | 14.5 x 21 cm;
graphite pencil and felt pen.

"A few years ago, I worked in Berlin for a while and didn't draw as much as I wanted to, so I made a habit out of drawing people on the bus every morning."
—Sebastian Koch

SKETCH HERE!

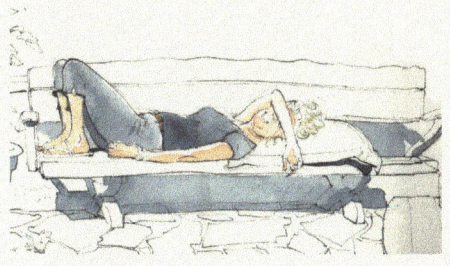

KEY V
COLOR & LIGHT

Capturing light as it falls on a person's body is a sure way to bring it to life, as you're suddenly introducing a third dimension. Whether you like to color your sketches or leave them monochrome, you'll get lots of enjoyment from making them glow in a pool of light. Depicting light is really adding shadow: Painting light is leaving out color, the contrast between light and shadow giving you the glow you need.

When it comes to color, there's no need to fear a clash or strange, unrealistic skin or hair tones. In this chapter, I share how color can be straightforward and is best achieved with a small palette. Color is the magic that makes people look twice! I recommend making color as much a part of your voice as your line.

⌒ RÓISÍN CURÉ
Fiona in the Sun
A4 (8¼" x 11½" | 21 x 29.7 cm)
AMI watercolor sketchbook, carbon pen, grey ink, and watercolor.

COLOR AND ITS ABSENCE

Light, in watercolor terms, is the absence of color. You can get away with a slick of very dilute yellow, but it's better to err on the side of "glow" and put nothing at all on the figure, especially if you are depicting strong sunlight. The exception to this is if you are sketching on toned paper: When the paper is not white, practice drawing "light" with white gel pens, pastels, or gouache.

To know how to leave color out, you need to know how to put color in.

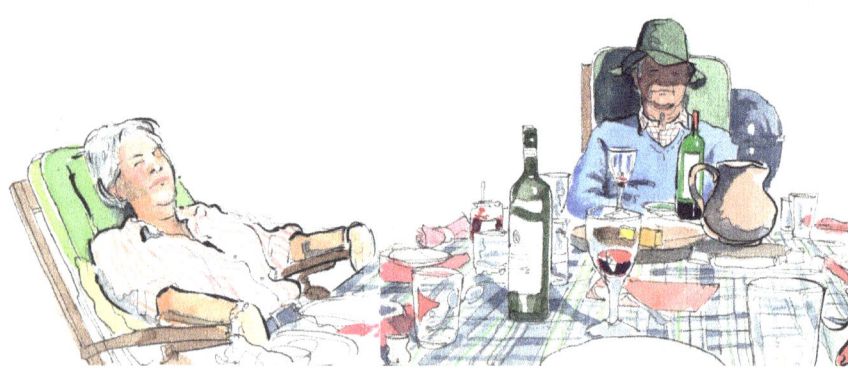

◯ Each part of this image has more or fewer layers, depending on the shadow they're in. In watercolor, layering is crucial. The more thinly the layers are applied, the less transparent and the more "shaded" the result.

RÓISÍN CURÉ
Easter Monday
A5 (5¾" x 8¼" | 14.8 x 21 cm) AMI sketchbook (double spread), carbon pen, ink, and watercolor.

Tip

Keeping colors to a minimum reduces some of the issues involved in trying to capture a human form quickly under pressure. A surprisingly small range of colors can produce an astonishing variety of tones.

MY HUMAN PALETTE

My human palette is good for hair, skin, and clothes, but experiment with a range of your own choosing.

- Opera pink
- Lemon yellow
- Yellow ochre
- Burnt umber
- Indigo
- Payne's grey
- Green apatite genuine
- Transparent red oxide
- Chrome orange

With these nine colors, you can do any skin or hair color, and a wide range of clothing colors—without clashing. But feel free to choose your own or any version of the colors I mentioned: Remember, your color choice is as much a personal choice as any other aspect of your sketching practice.

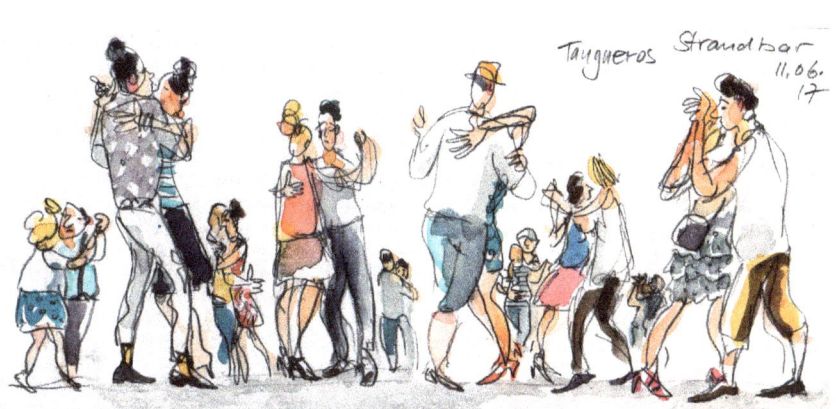

◑ Straight lines through the leading partners lend weight and balance to the stance, while the loose splashes of color bring a fresh, lively air to the scene. Note the easy skill in making (cleverly placed) figures in the background look further away by reducing their scale.

DETLEF SURREY
Tango Dancers
12" x 5⁵⁄₁₆" | 30 x 13.5 cm;
4B pencil and watercolor.

Hair

Straight hair is lighter in a band around the crown where the light hits it (this can be white and unpainted).

- The straighter the hair, the sharper the line between the hair color and the shiny part. Soften the color next to the band of shine.
- Curly hair doesn't have that shiny band but has a corona of slightly lighter coloring around the top side of the hair.
- Get scribbly and don't be too neat; it looks more natural.
- Don't forget wispy bits, but always try to remember the direction of hair growth.
- Let the wind play a part in the way you draw hair.
- Use a few shades when painting hair in a close view; it looks more natural and more alive.
- Leave a rim of light at the edge if you're not too close to your subject; it lifts the hair wonderfully.
- Hair is darker at the roots and nape of the neck and when you are looking through strands to hair at the back.
- Hair of older people is wispy and fine. Use a fine nib, or the fine side of your pen.
- White hair can be left white and unpainted.

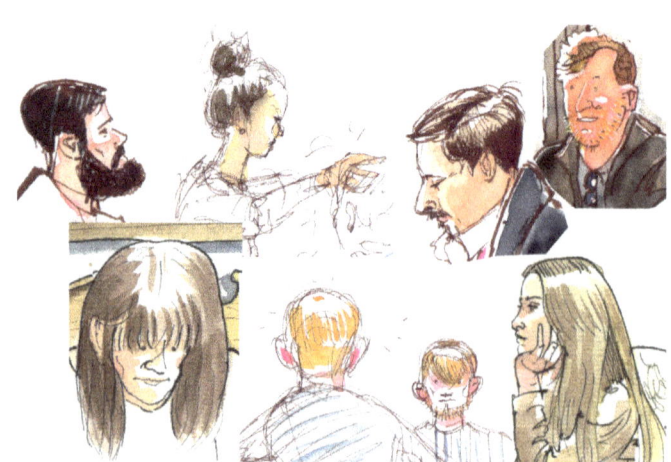

Skin

A wide range of colors can be achieved with different dilution of each and mixing them in various proportions. Practice mixing the colors together to get a range of colors that look natural for skin. This is how I mix colors for various skin tones:

- Yellow ochre + opera pink in varying proportions = pale skin tone
- Yellow ochre + opera pink in varying dilutions = pale to medium skin tone
- Transparent red oxide + yellow ochre = medium skin tone
- Burnt umber + transparent red oxide = medium to dark skin tone
- Burnt umber + Payne's grey = dark skin tone

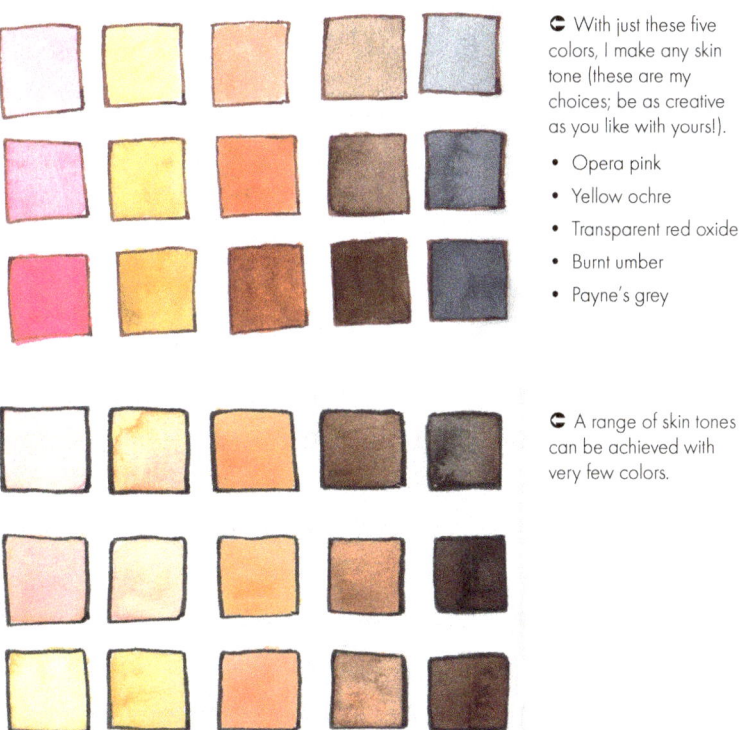

↶ With just these five colors, I make any skin tone (these are my choices; be as creative as you like with yours!).

- Opera pink
- Yellow ochre
- Transparent red oxide
- Burnt umber
- Payne's grey

↶ A range of skin tones can be achieved with very few colors.

⊃ A touch of pink goes a long way.

RÓISÍN CURÉ
Caroline
4¹¹⁄₁₆″ x 4¹¹⁄₁₆″ | 12 x 12 cm
AMI watercolor sketchbook,
carbon pen, and watercolor.

No matter the skin color, I like to mix my base color, then add a little pink to warm it up slightly. Keep that touch of pink to a minimum; drop a tiny blob of paint into the color you have painted on the page, and let the water do the blending.

Diluting your color will give you great powers of subtlety and range. It can be a tricky thing to master, so practice, practice, practice. Remember: Wet onto wet, wet onto dry, but not wet onto half-dry.

The next section (see page 86) looks at combining light with color to make skin glow.

How Dilution Works

In watercolor, the way to make a color lighter is to add water. As a sketcher of people, the ability to get an almost infinite range of tones is valuable. When you're painting skin, dilution is vital. Skin shades are delicate and subtle. Skin is smooth and can have a gentle glow, so you need to dilute your color, fading it to clear water, to show that lovely texture.

1. Clean a brush in water, wipe excessive water on the edge of the container so it is just damp, and dip the brush into the pan of paint. Transfer color onto a clean area of your palette.
2. Transfer a small amount of color onto another part of your palette. Add a small amount of clean water and you have a diluted, lighter version of your paint.
3. Use your absorbent paper sparingly: Use your brush as a mop rather than dabbing directly with the paper.

Cleaning Off a Blob

It's easy to create an accidental blob or a color too rich for skin tone. But it's not hard to fix, either.

1. Immediately add lots of clean water to the blob; do *not* dab it with a tissue. You only get one go with a dab; after that you won't clean any more off.
2. Next, mop off the excess water with your brush. Wipe the brush on your tissue.
3. Wash your brush vigorously between each mopping action.
4. Finally, blot the damp area with a clean tissue.

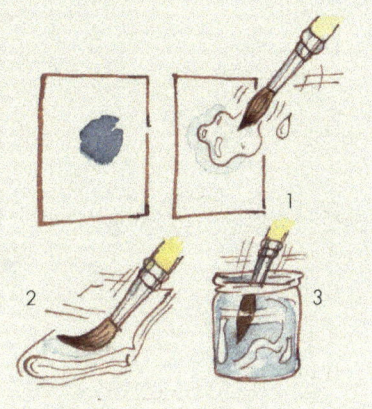

Tip

If you want a smooth surface in watercolor, the most important thing you do is—nothing. This probably applies to skin more than anything, due to the delicate nature of the surface of skin. You must leave it to dry. Do not be tempted to smooth out the brushstrokes with your brush, because you'll make it worse. Do not add fresh paint to half-dry paint, as you will create a "bloom" or cauliflower, which is nearly impossible to fix. I have learned to embrace them as part of the signature of watercolor.

Clothes

There are as many colors for clothing as there are colors in the world. Personal taste reigns, but you are less likely to clash if you stick to fewer colors.

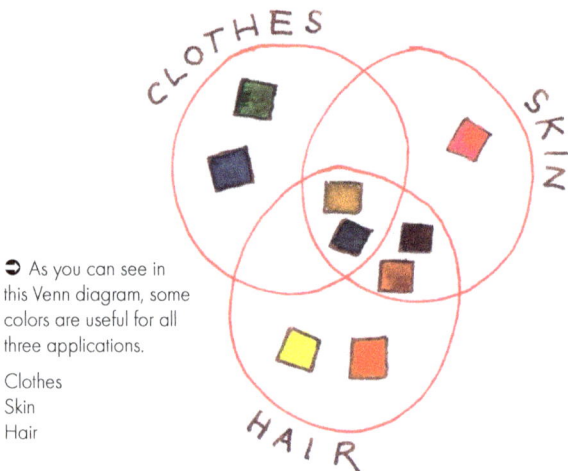

⊃ As you can see in this Venn diagram, some colors are useful for all three applications.

Clothes
Skin
Hair

Expressing Individuality

Drawing patterns on clothing, and the accessories people wear, can be lots of fun. Watch for spots, stripes, checks, and tattoos.

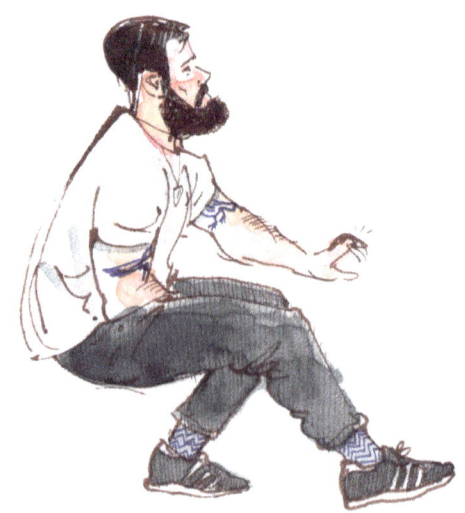

⊃ Tattoos can be a big part of someone's look. Keep it simple to let the interesting bits stand out.

Johnny Magpie

5½" x 5½" | 14 x 14 cm; Hahnemühle watercolor sketchbook, fude pen, ink, and watercolor.

Borrowing Background Colors

Identify stand-out colors of the setting and repeat them in the clothing palette. Use the interior designer's color theme and pick out parts of it in the clothing of your subjects, even if it means adjusting both.

Turning Up the Volume on Color

Exaggerate the colors: Turn up the volume, so to speak, to get a sketch with impact.

Tip

A white gel pen is invaluable for clothing patterns, but make sure the base color is dark or the white won't stand out.

↻ Don't be afraid to adjust colors for maximum effect. The dragons on this shirt were gold, but they stood out more in white.

Waiting for Our Flight
A5 (5¾" x 8¼" | 14.8 x 21 cm)
Hahnemühle watercolor sketchbook, fude pen, ink, watercolor, and white and gold gel pens.

All artwork on this spread: **RÓISÍN CURÉ**

Tips for Drawing Stripes and Spots

- Let stripes define and describe the contours of a body; look for how they appear and disappear.
- Curve a stripe to suggest the curve of an arm.
- Stripes are a very good way to tell the viewer about the drape of a garment.
- Dots are closer together as they near the edge of a curved surface.
- Spots lift a garment wonderfully, whether dark spots on light, or vice versa.

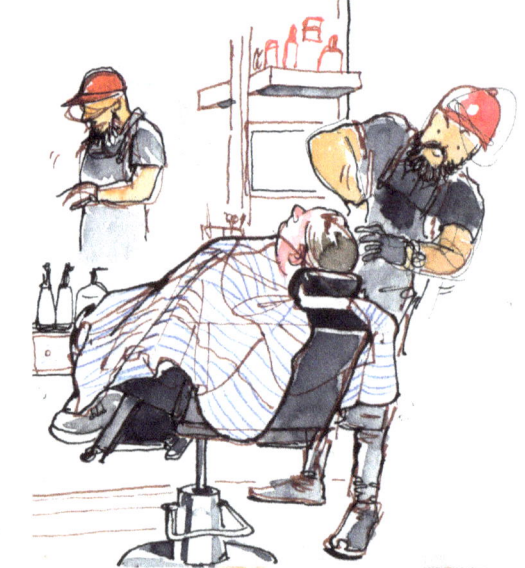

⮕ You can mix your media for efficiency, such as a colored pencil, to get the energy of stripes.

A Relaxing Shave

A4 (8¼" x 11½" | 21 x 29.7 cm) Hahnemühle watercolor sketchbook, fude pen, ink, and colored pencil.

⮕ *Lunch at the National Gallery* (detail)

A4 (8¼" x 11½" | 21 x 29.7 cm) Hahnemühle watercolor sketchbook, fude pen, ink, and watercolor.

All artwork on this spread:
RÓISÍN CURÉ

◐ One of the very rare times someone didn't look completely happy to be sketched. If you forget to observe the curve of the stripes—as I did in this sketch—just look again and draw them right on top.

Frenchman with a Tattoo

4¹¹⁄₁₆" x 5⅞" | 12 x 15 cm
Hahnemühle watercolor sketchbook, fude pen, ink, and watercolor.

◒ Stripes can be a wonderful highlight of a sketch. The faster and bolder you draw your stripes, the more energy they will have. Paint them with the tip of your brush for a fresh and vibrant effect. Stripes break off and start again—like fault lines after an earthquake—to show folds. Let them show curves.

Olivia in the Sun

A5 (5¾" x 8¼" | 14.8 x 21 cm)
Hahnemühle watercolor sketchbook, fude pen, ink, and watercolor.

Patterns, Checks, and Plaid

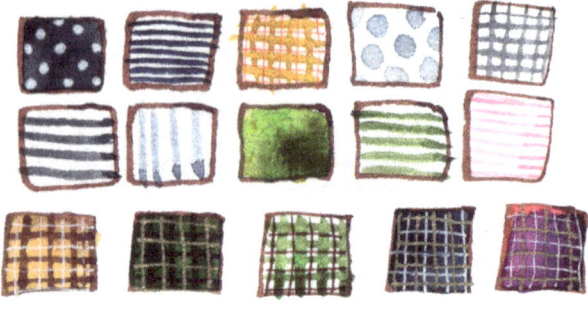

◐ With the colors suggested in the palette on page 75, a great variety of patterns can be produced. A plaid shirt is a gift to a sketcher. Paint the base color and wait for it to dry. Draw or paint stripes on top, putting different colors in different grids. A gel pen is great for this.

◐ The looseness of lightly painted plaid can be a lovely counterpoint to a carefully observed drawing.

Darragh
A4 (8¼" x 11½" | 21 x 29.7 cm)
Hahnemühle watercolor sketchbook, fude pen, ink, and watercolor.

All artwork on this spread: **RÓISÍN CURÉ**

Drape

⊃ Stripes can also help define the drape of fabric. Look for vertical lines where the weight of the fabric causes it to hang.

Stan

A4 (8¼" x 11½" | 21 x 29.7 cm) AMI sketchbook, carbon pen, ink, and watercolor.

Creases

Fabric creases; skin doesn't. Allow creases to be loose and free, just like the random way they come. In time, the creases will replace the imagined edges of a garment—with the first pull of a line.

You're going to draw a lot of denim, hoodies, woolen sweaters, and jackets—a whole world of creases. Crease hotspots include:

- Inside hoods
- Elbows and wrists
- Knees and ankles
- At the torso, especially where a sweater meets the hips
- At the groin, where the legs become a torso

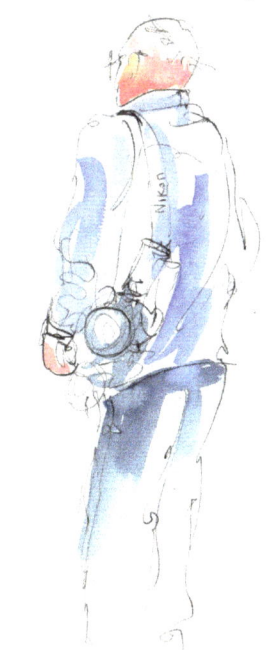

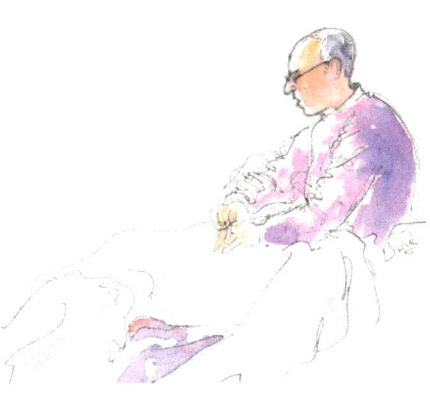

↥ Well-observed creases can make light work of a foreshortened limb.

Sewing a Sail

11½" x 6³⁄₁₀" | 30 X 16 cm AMI watercolor sketchbook, carbon pen, ink, felt-tip pen, and watercolor.

↥ The fresher the crease, the more realistic it looks. Follow the contours you can see.

The Redhead

A4 (8¼" x 11½" | 21 x 29.7 cm) Hahnemühle watercolor sketchbook, carbon pen, ink, and watercolor.

LIGHT AND SHADOW

Now that we've looked at adding color to a sketch, we're going to talk about bringing in a sense of light by taking it away.

With practice, you'll find you paint *less*. You will notice the dark and light areas faster and faster with time, and your confidence in leaving color out—which is sometimes counterintuitive—will grow.

- Facing the scene you want to sketch, half-close your eyes. The darks and lights will immediately jump out at you. First, paint the lightest areas. Wait for the paint to dry. Then look for the shadows and carefully paint them on top.
- Look for areas that are thrown into shadow: Under the brim of a hat. Below the edge of a sleeve. The knees or shins under the hem of a dress.
- Shadows come in different colors. When adding areas in shadow, try to darken that particular color rather than just making it "dark" or gray. To darken skin, add a less dilute version of the color you used for the part of the face in the light. In strong sunlight, the border between light and dark should be crisp and sharp.

All artwork on this spread:
RÓISÍN CURÉ

🜂 A strong sense of light is achieved by leaving a corona of unpainted area on the light side of clothes, skin, and hair.

Bar in Largo de São Domingos, Porto
A4 (8¼" x 11½" | 21 x 29.7 cm) 300g Fabriano paper in a homemade concertina sketchbook, fude pen, ink, and watercolor.

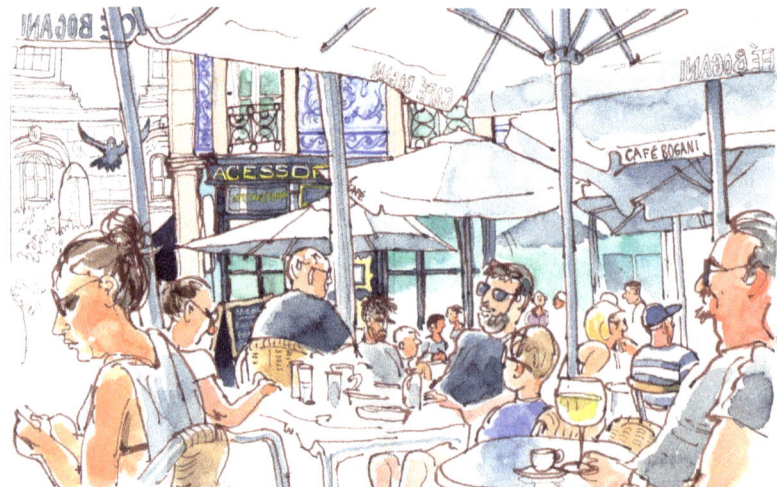

Skin, Clothes, and Hair

What skin, clothes, and hair have in common when it comes to light:
- A rim of light around the edge manifests with an absence of color.
- If the light is strong, the line is sharp.
- If the light is soft or overcast, the line is blended and soft.

How skin, clothes, and hair are different when it comes to light:
- A face has lots of planes and each comes with its own little peak and trough of light and shadow.
- Hair has a corona of light near the top of the head.
- Clothes are easier—just slabs of color and pattern with unpainted or lighter areas where light is hitting the figure.

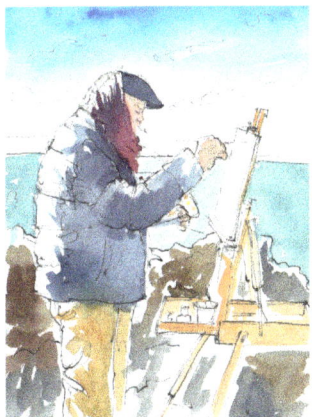

◐ In frigid weather, you'll find it hard to paint layers, because they just won't dry. But the wet-on-wet technique that happens when other options are limited can be beautiful.

Blaise
A4 (8¼" x 11½" | 21 x 29.7 cm) AMI watercolor sketchbook, carbon pen, ink, and watercolor.

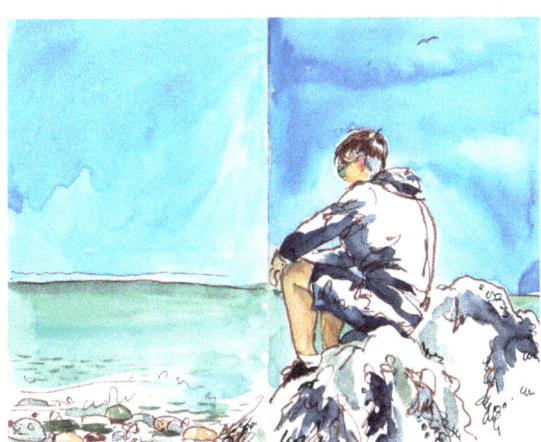

◐ In strong sunlight, leave even dark colors white. The glow will be lost with any paint.

Paddy in Sunlight
A5 (5¾" x 8¼" | 14.8 x 21 cm) Fabriano Venezia sketchbook, fude pen, ink, and watercolor.

⊃ The sun makes colors lose intensity and patterns lose definition. Also, observe how shadows can say a lot about the contours of the body.

Lily

A4 (8¼" x 11½" | 21 x 29.7 cm) AMI watercolor sketchbook, carbon pen, ink, and watercolor.

All artwork on this spread:
RÓISÍN CURÉ

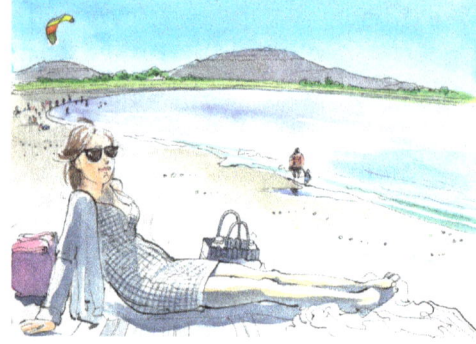

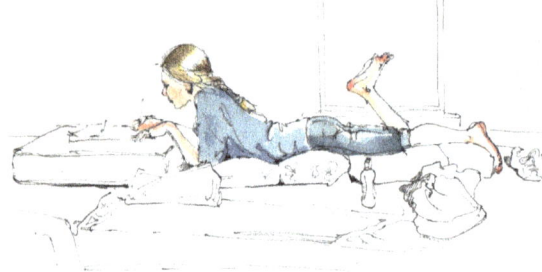

⊂ In strong sunshine, hair can take on an almost ethereal glow.

Homework Outside

A4 (8¼" x 11½" | 21 x 29.7 cm) AMI watercolor sketchbook, carbon pen, gray ink, and watercolor.

Shadows

A little shadow can make all the difference. If you are lucky enough to encounter someone who is not intent on movement for a while, get stuck into those blue shadows.

If the sun is out, take your time and enjoy yourself. However, if you are in danger of losing the sun to a cloud, use a thin nib to outline your shadow: that way you won't be left in the dark, so to speak.

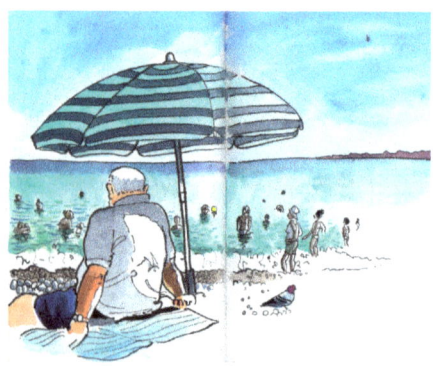

⊂ Pinpoint the main color in your scene, then see if you can find or slightly adjust colors to harmonize.

Italian on the Beach, Nice

11" x 9" | 28 x 23 cm Fabriano Venezia sketchbook, fude pen, ink, and watercolor.

Key V: Color & Light | 89

◐ To help make a surface look curved, observe a slightly darker part in a shadow just before the border with the lighter area.

Olivia at Mulroog

A4 (8¼" x 11½" | 21 x 29.7 cm) AMI watercolor sketchbook, carbon pen, ink, and watercolor.

There's a lot more to the light as it hits a body than there is to the hair or a clothed body: There are so many planes, and light is a delicate thing.

When painting the face, consider the following:

- The planes on the face
- The way light hits the nose (on which side does it fall?)
- Shadows under the lower lip, the nose, the eye sockets

◐ Determine which direction the light is coming from, then exaggerate it. Unless you're doing a close-up detailed portrait, you'll need more dramatic highlights to achieve a striking effect. Remember the planes of the face: Which are in shadow? Which are highlighted?

Engrossed

3⅞" x 3⅛" | 10 x 8 cm
Hahnemühle watercolor sketchbook, fude pen, ink, and watercolor.

◐ Look at how wet skin differs from dry: the sharp-edged highlight on wet skin, the softer highlight on dry skin. The beach is the ideal place to experiment, and it's where you'll find people relaxing and keeping still for long periods.

Symphony of Swimsuits

A5 (5¾" x 8¼" | 14.8 x 21 cm) Fabriano Venezia sketchbook (double spread), fude pen, ink, and watercolor.

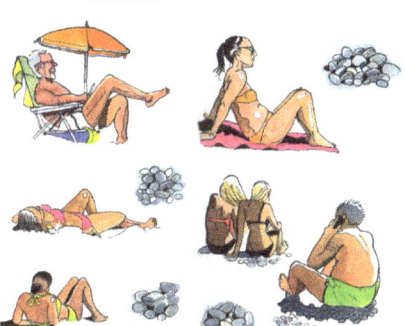

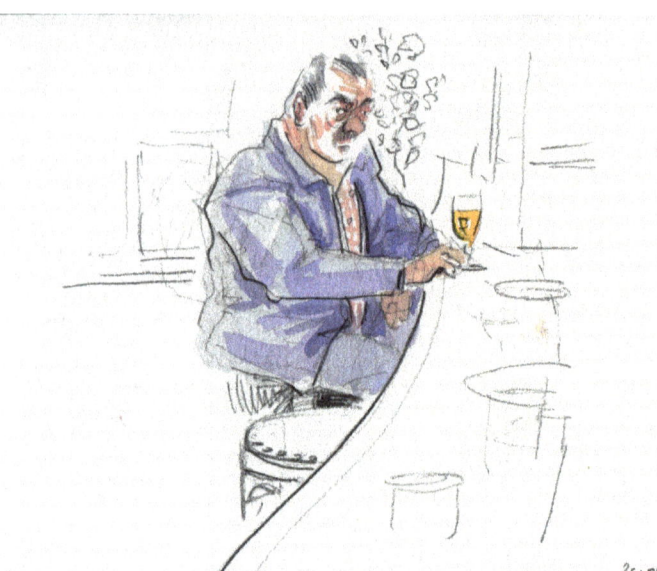

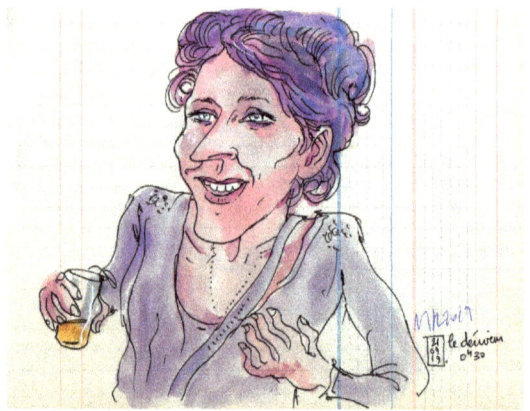

↑ Coloring only the figure is an effective and efficient way to capture the focus of interest.

MARTA FONFARA
Jeanou
8½" x 10⅝" | 21 x 27 cm; black pencil and watercolor.

"I sketched this super-late in a bar on the last day of an artistic residency in Saint-Briac sur Mer (Brittany)."
—Lapin

↑ The light in the subject's eyes is a window into her soul.

LAPIN
Marion Rivolier
8⁵⁄₁₆" x 5⅞" | 21 x 15 cm; ink pen, watercolor, and Gelly Roll pens on old accounting paper.

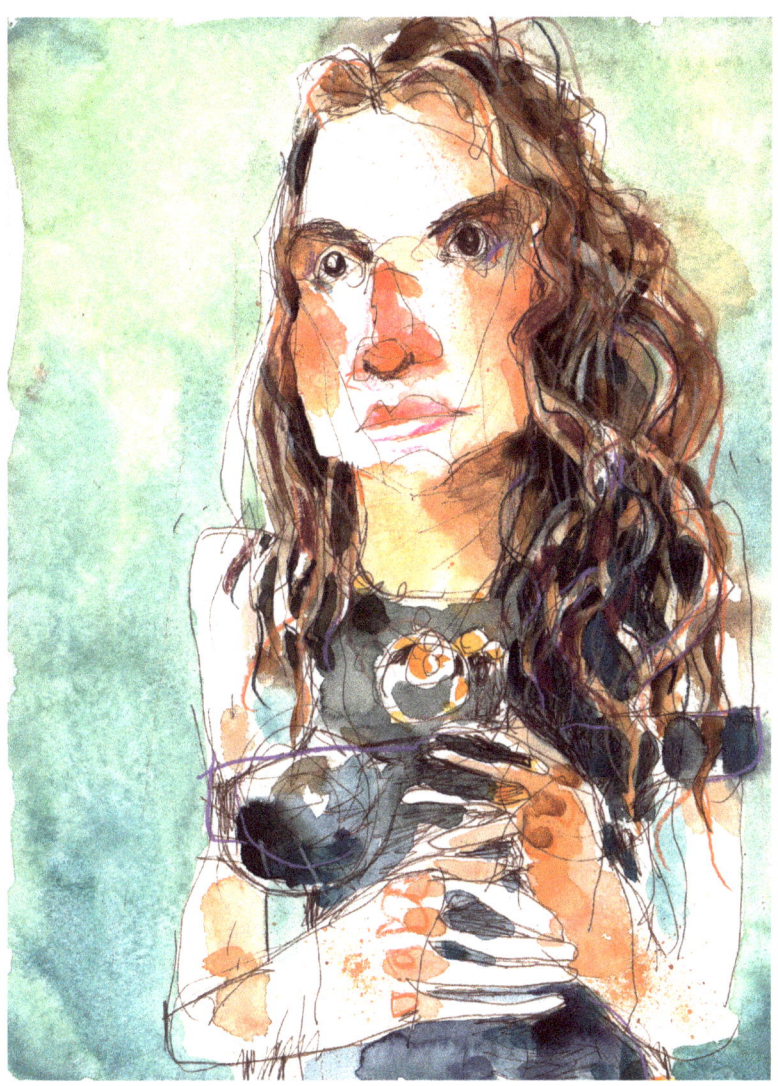

🎧 The artist breathes life into the subject's hair by the creative use of color—purple, orange, and pink—which somehow combine to make it even more natural. The color in the subject's face infuses her with serenity and personality.

FELIX SCHEINBERGER
Anna
11¹³⁄₁₆" x 15¹¹⁄₁₆" | 30 x 40 cm; ink and watercolor.

SKETCH HERE!

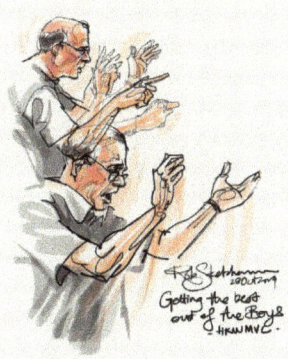

GALLERIES

My sketches are, for the most part, in pen and ink, with watercolor to color. That's because I fell helplessly in love with the inked line at a very young age, and I adore the fluid nature of watercolor. But the sketches in these galleries stretch the definition of "sketching tool" to its very limits, in the most creative ways imaginable. Here, you'll see collage, colored pencils, stamps, brush pen, watercolor on its own, and the humble pencil. There's great beauty in the variety of tools and lots of inspiration to be gleaned. You'll see tremendous sensitivity, and many personal stories, in the subjects chosen and sketched by the artists here. The stories they convey are universal and touching. I hope you'll be inspired to make personal sketches and stories of the people in your life, too.

↑ Just look at the movement in this drawing of a choir conductor. The many hands tell a story of wildly rhythmic movement.

ROB SKETCHERMAN
Welsh Male Voice Choir Conductor
iPad and Procreate

I. ON THE MOVE

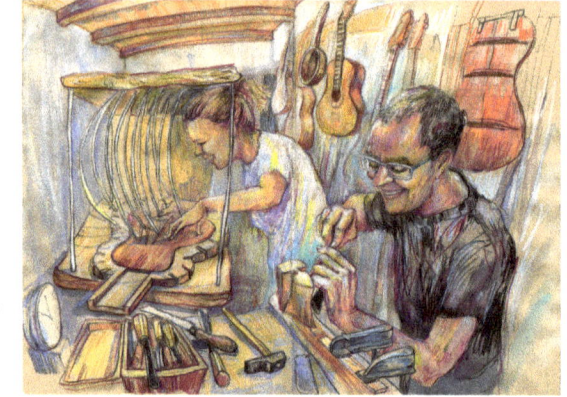

⤴ **CELIA BURGOS**
Luthiers Fernando and Eva
16½" x 11½" | 42 x 30 cm;
Polychromos colored pencils
and watercolor.

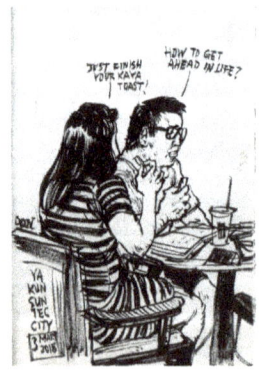

⤴ **DON LOW**
*Coffee Break at
Suntec City*
5⅞" x 8½" | 15 x 21.5 cm;
Pentel brush pen in
sketchbook.

"I like to use patterns or textures on fabric to show the form of the figure, especially stripes. If drawn nicely, the stripes will show the roundness of the figure, and indicate depth, too."
—Don Low

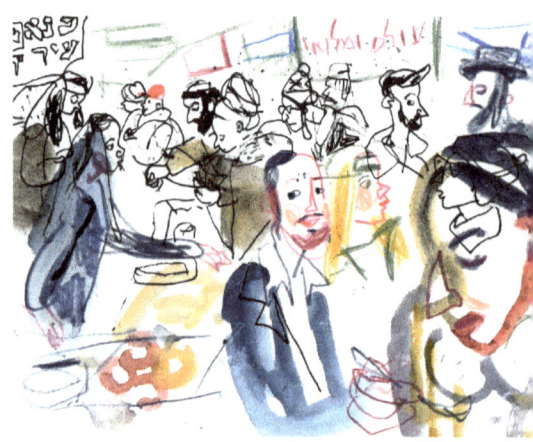

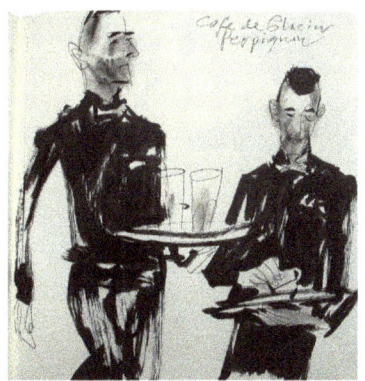

◐ The straight back of the waiter on the left and the way the arm is held away from the body lend an air of speedy efficiency to the subject. Those glasses are in no danger.

JOHN SHORT
French Sketchbook: Waiters in Café, Perpignan
7½" x 7½" | 19 x 19 cm; pen and brush pen.

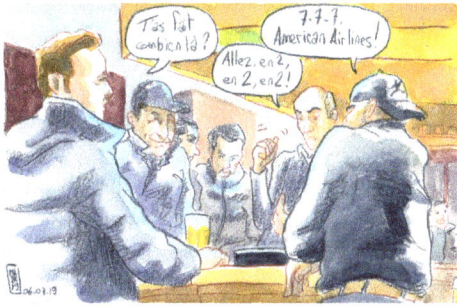

◐ The movement of a fist throwing dice is captured so well that the unseen dice is clearly imagined. The focused gazes of the players direct the viewer to the game at hand.

MAT LET
The Dice Players
A5 (5¾" x 8¼" | 14.8 x 21 cm); Polychromos colored pencils and watercolor.

"I love to find stories in everyday routines, and I combine sketching with daily tasks. All you need is a sketchbook and a simple pen to go on a journey every day. Drawing is seeing; open your eyes and sketch."
—Marina Grechanik

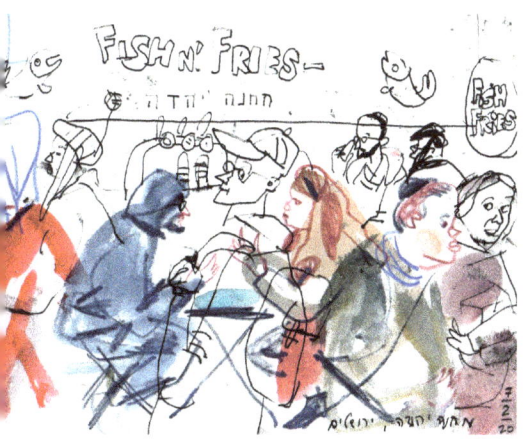

◐ The great variety of colors in bold strokes brings huge energy to the scene.

MARINA GRECHANIK
Market People in Jerusalem
19⁵⁄₁₆" x 6⁷⁄₈" | 49 x 17.6 cm; watercolor, colored pencils, fountain pen.

Qi Gong UCLA Medical Center Plaza 12/12 VHein

"I was entranced by two gentlemen of advanced age moving with calm, fluid grace in the Plaza of the UCLA Medical Center. One was a master, the other man mirroring his movements. The calm yet intense focus was mesmerizing, and I tried to catch the flow of movements, one rolling into the next."
—Virginia Hein

◐ **VIRGINIA HEIN**
Qi Gong
A5 (5¾" x 8¼" | 14.8 x 21 cm)
Moleskine watercolor album, fude pen with black document ink.

◑ **TAZAB**
Café, Amsterdam
A5 (5¾" x 8¼" | 14.8 x 21 cm); 0.5 mm felt-tip pen.

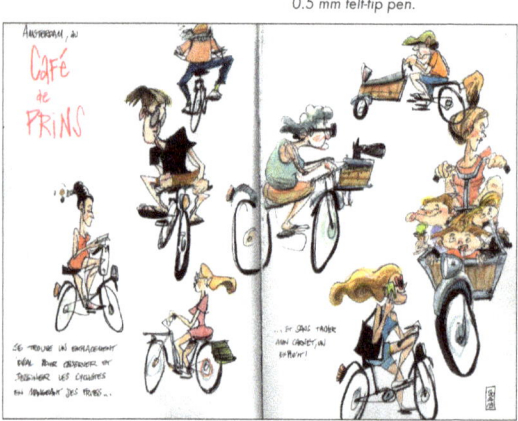

"I found the ideal spot to observe and draw cyclists while I ate fries, and I didn't even get any on my sketchbook—quite the achievement!"
—Tazab

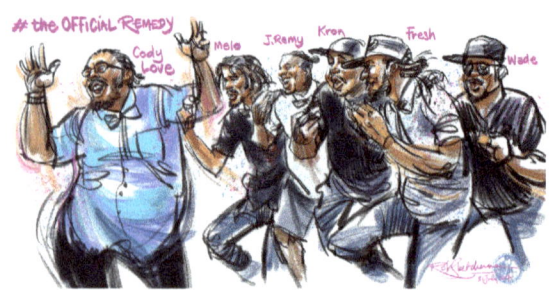

◓ You can't see this sketch and not feel the energy. It takes a true master to not just capture the movement, but to also have the dancers in step.

ROB SKETCHERMAN
The Official Remedy, Chicago
iPad and Procreate

II. LIGHT & SHADOW

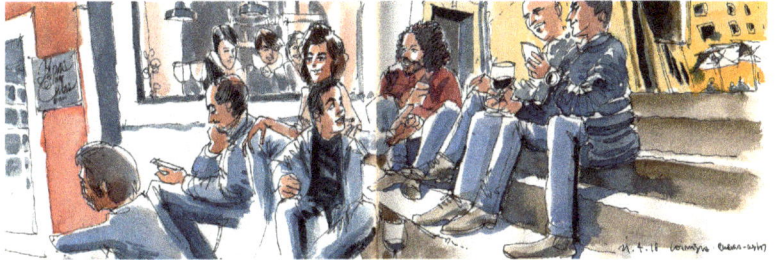

🎧 No figure deviates from having its left side bathed in white light, bringing a strong sense of a moment caught in time.

PEDRO LOUREIRO
Quebra Costas, Coimbra
A5 (5¾" x 8¼" | 14.8 x 21 cm)
Hahnemühle watercolor book (landscape).

↻ **PEDRO LOUREIRO**

Lisbon Make-up School Sessions
A5 (5¾" x 8¼" | 14.8 x 21 cm)
Hahnemühle watercolor book (landscape).

"Make-up is all about highlighting and sculpting features. I held a sketching workshop during one of the make-up teacher's classes, where the students tried to mimic those lessons in their sketchbooks.... all about light and shadow!"
—Pedro Loureiro

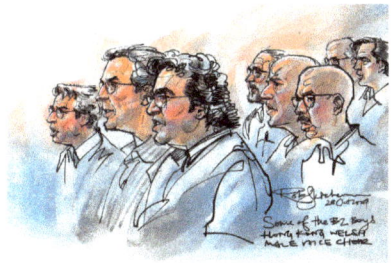

🎧 You can feel the power of the men's jaws as they enunciate their lyrics and deliver them with force. Note the play of light on each face.

ROB SKETCHERMAN
Hong Kong Male Voice Choir
iPad using Procreate.

⮑ Sharp borders between patches of color tell of strong sunlight. The figure is drawn with beautifully observed lines that suggest solidity and balance.

DETLEF SURREY
Urban Garden
A5 (5¾" x 8¼" | 14.8 x 21 cm); fountain pen and watercolor.

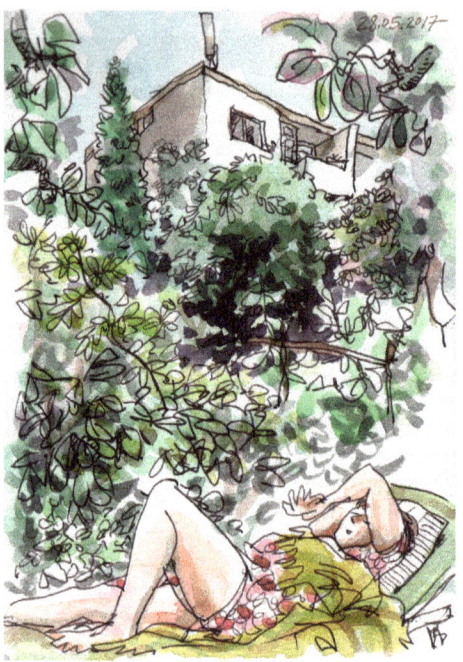

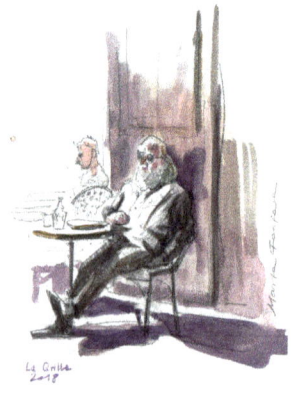

⮑ Purple shadows and areas left unpainted combine to give a figure who looks thoughtful and serene. The light on the sunglasses is a subtle but effective touch.

MARTA FONFARA
La Grille, Paris
5½" x 7⅞" | 14 x 20 cm; pencil and watercolor.

"I love to capture people live, in cafés, parks, and metros."
—Marta Fonfara

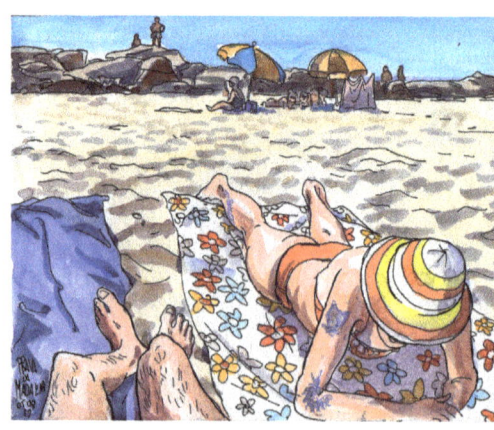

⮑ The light is beautifully conveyed here with the purplish-blues so often seen in Portuguese urban sketches.

PAULO MENDES
Madalena Beach
A5 (5¾" x 8¼" | 14.8 x 21 cm); pen and ink and watercolor.

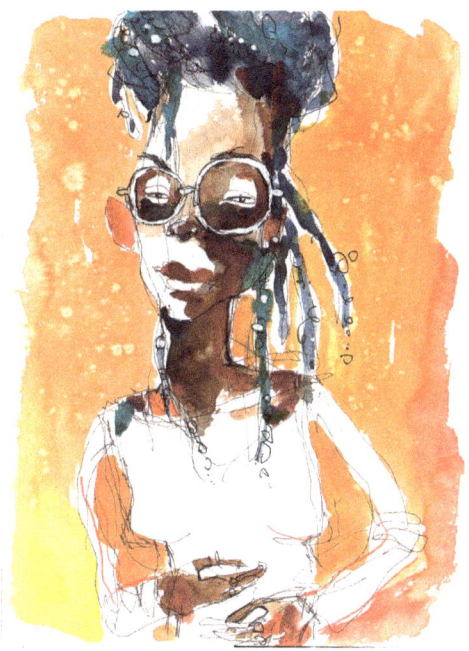

◐ No matter how light or dark the tone of skin, leaving it completely white on the lit-up side gives the effect of strong sunlight.

FELIX SCHEINBERGER
Medine
A4 (8¼" x 11½" | 21 x 29.7 cm); ink and watercolor.

"The essence of urban sketching is finding stories in the everyday."
—Marina Grechanik

◑ Heavier lines on the dark side of each figure help to suggest shadow.

MARINA GRECHANIK
Couple Eating Hummus
16½" x 5⅞" | 42 x 15 cm; ink.

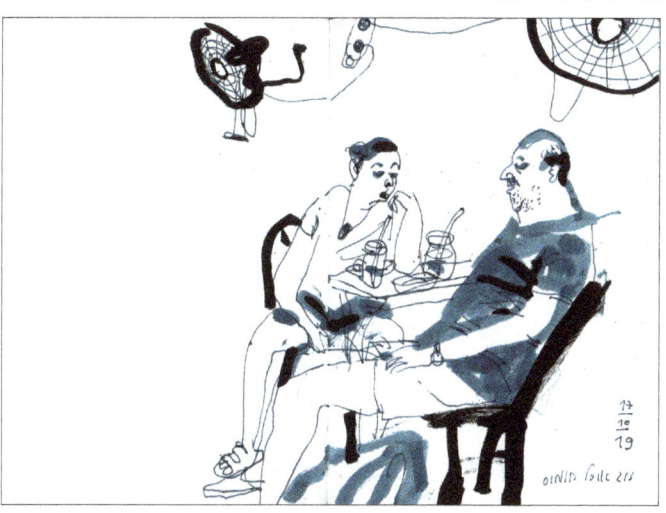

III. CREATIVE COLOR

⊃ **CELIA BURGOS**
José Luís Cuerda
11¹¹/₁₆" x 8⁵/₁₆" | 29.7 x 21 cm
(double spread); Polychromos
colored pencils and watercolor.

"While drawing the famous Spanish director José Luís Cuerda, his words made me think, laugh, and learn in equal measure. Only a year later, the director passed away. It was a privilege to be able to draw and listen live to such a creative and charismatic person."
—Celia Burgos

⊃ The color in this sketch is all about the subject's red hair and indigo dress. On the skin, a hint of thoughtful color can go a long way. Note the variety of shades in the hair, adding life and interest.

FELIX SCHEINBERGER
Natascha
A5 (5¾" x 8¼" | 14.8 x 21 cm)
(double spread); ink and watercolor.

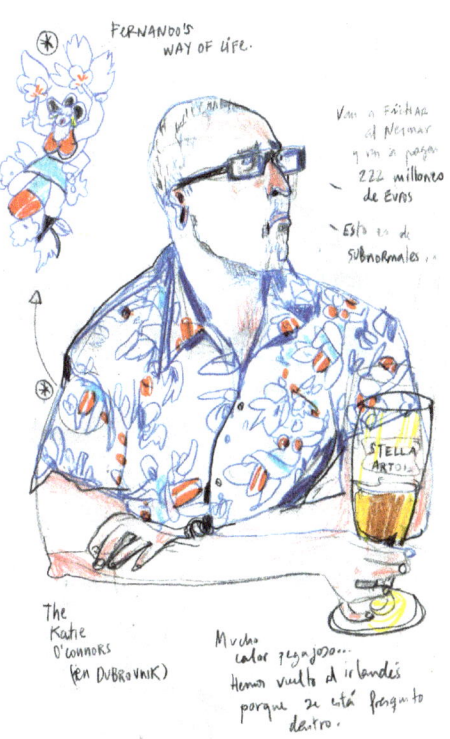

◑ A simple sketch of a friend having a beer is transformed into something of great vibrancy through the playful motif on the shirt, repeated at the top of the sketch for added fun and interest.

INMA SERRANO
Pub in Dubrovnik
A4 (8¼" x 11½" | 21 x 29.7 cm); colored pencils and watercolor.

◔ The use of bold and inventive color somehow captures a gentle expression.

MARIELLE DURAND
Left-Hand Drawing
A5 (5¾" x 8¼" | 14.8 x 21 cm); colored pencils.

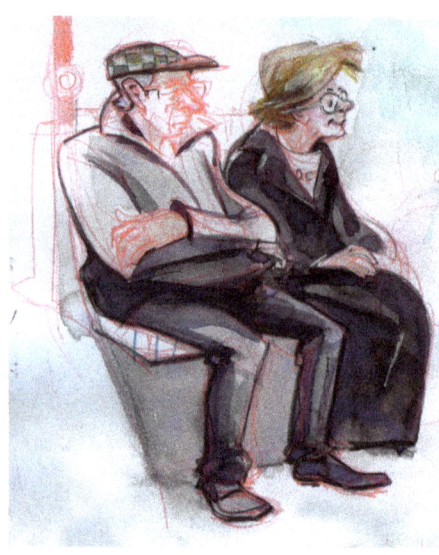

↻ Red lines in watercolor pencil are quick and strong and bring energy to the sketch. Their rough power is an intrinsic part of the finished sketch.

NICOLA MAIER-REIMER
Couple on the Bus
A5 (5¾" x 8¼" | 14.8 x 21 cm) Hahnemühle watercolor sketchbook, colored pencil, watercolor, and opaque white.

↺ Inventive use of color suggests the light of a bar, the simple range of color giving unity to a busy scene.

SYLVAIN CNUDDE
Social Bar
A4 (8¼" x 11½" | 21 x 29.7 cm); Chinese ink in brush pen and watercolor.

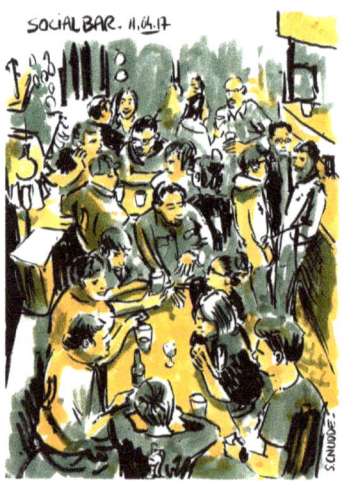

↻ **SEBASTIAN KOCH**
People at the Station
A5 (5¾" x 8¼" | 14.8 x 21 cm); felt pen and colored pencils.

"In the local station, there's a bakery with a few tables to sit and eat or have a coffee. It's a good place to draw people queuing for pastries or rushing by to catch their train."
—Sebastian Koch

◐ VIRGINIA HEIN
The Getty in Red
A4 (8¼" x 11½" | 21 x 29.7 cm)
Moleskine watercolor album,
Derwent terra-cotta drawing pencil,
and watercolor.

"I love sketching people in the clear afternoon light at the Getty Center in Los Angeles. I went to see the drawings by the Renaissance master Andrea del Sarto. Many of these were in red chalk, and I was immediately inspired to make this sketch in the same terra-cotta red."
—Virginia Hein

☾ OMAR JARAMILLO
Guys Playing Bao
8⅓" x 6³⁄₁₀" | 22 x 16 cm;
Water-resistant pen
and watercolor.

"These guys in Tanzania were playing bao, a traditional African game. The guy on the left had had a stroke, the reason for the unusual position of his body. He was amazed that it was clear from the drawing."
—Omar Jaramillo

OLIVER HOELLER
Airport Transit
8" x 10" | 20.3 x 25.4 cm; fineliner, watercolor, and white acrylic pen.

⮂ The humble pencil, with his distinctive line, is all this artist needs to make an expressive and sensitive sketch. The tinted paper plays a large part in the interest of the sketch.

BEHZAD BAGHERI
Old Man in Isfahan Grand Bazaar
4⁵⁄₁₆" x 7⅞" | 11 x 20 cm; pencil.

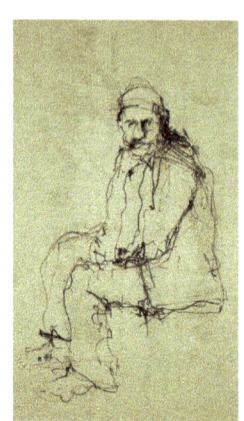

"I have color-coded the crowds here. It helps to visually separate the sketch into different zones of the airport."
—Oliver Hoeller

JENNY ADAM
Vor Ort Drink and Draw, Mainz
15" x 5" | 38.1 x 12.7 cm; watercolor.

MÁRIO LINHARES
Creative with Color
5⅞" x 16⅛" | 15 x 41 cm; Lamy nib pen, watercolor, bits of ice cream!

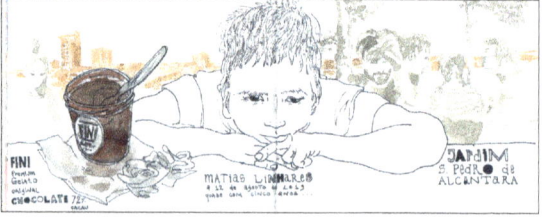

"Changing the media between the main topic of the drawing and the background is one of my favorite options to bring the context in without competing with the story of the sketch."
—Mário Linhares

IV. CAPTURING MEMORIES

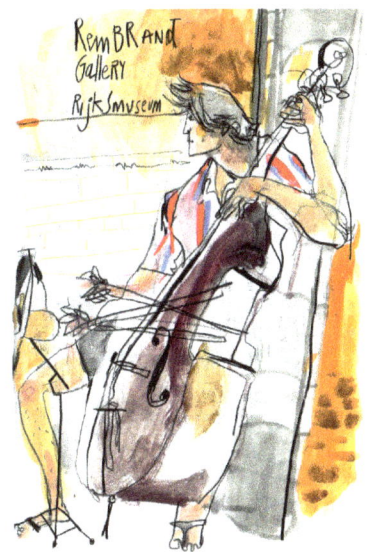

◐ Multiple arms suggest movement.

INMA SERRANO
Musician in Amsterdam
A4 (8¼" x 11½" | 21 x 29.7 cm); colored pencils and watercolor.

"This musician playing the cello produced rich and melodic tones on the way into the Rijksmuseum, adding an aural memory to the visual one."
—Inma Serrano

◐ Intense discussion between the chefs on the best way to cut up the sausage is caught in speech bubbles, a wonderful way to bring a moment to life and enhance the memory of the scene.

LAPIN
Jean-Fanch and Flunchy
8³⁄₁₀" x 6⅛" | 21 x 15.5 cm; ink pen, watercolor, and Gelly Roll pens on old accounting paper.

⊃ The hunched shoulders and forward tilt of the policeman lets the would-be protestor know he means business.

MAT LET
Locked Out
A5 (5¾" x 8¼" | 14.8 x 21 cm); fountain pen, waterproof ink, and watercolor.

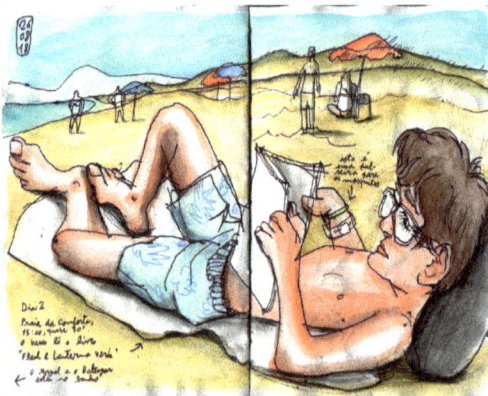

⊂ How charming to have such a lovely memory. Nelson uses a loose, free line and appears to sketch with great abandon.

NELSON PACIENCIA
People and Their Stories
A5 (5¾" x 8¼" | 14.8 x 21 cm); BIC ballpoint pen 1.6 mm and watercolor pencils.

⊃ A wonderful memory of children playing on the beach. These simple sketches make treasured memories.

NELSON PACIENCIA
People and Their Stories
A5 (5¾" x 8¼" | 14.8 x 21 cm); BIC ballpoint pen 1.6 mm and watercolor pencils.

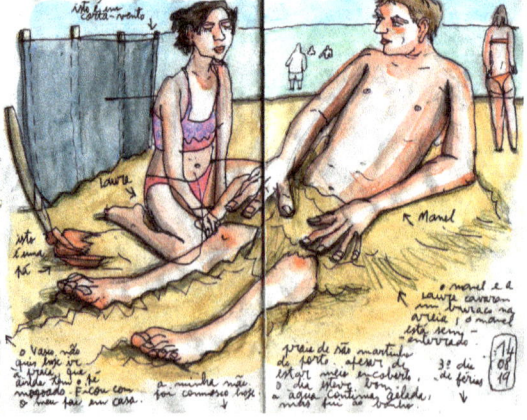

◔ MIKE DAIKUBARA
Ibuprofen

10" x 7" | 25.4 x 17.8 cm; Stillman and Birn Alpha series, fude pen, and Holbein watercolor paint.

"My wife and I were on a trip to Disneyland, and she had had a tooth out two days earlier. My wife is usually very beautiful, but wow! That sketch with the tooth out was exactly how she looked."
—Mike Daikubara

◔ The easy skill in this highly colored and finished sketch is a record of a unique moment in history.

PAULO MENDES
Lockdown Selfie

A5 (5¾" x 8¼" | 14.8 x 21 cm); pen and ink and watercolor.

◡ MURRAY DEWHURST
Trombone Practice

A4 (8¼" x 11½" | 21 x 29.7 cm) Hahnemühle Kraft sketchbook, Uni posca pens 8mm, and calligraphy pen 3.0 Artline.

"Sketching in toned sketchbooks with acrylic markers has completely changed the way I approach a sketch. I sketch backward: First I put down the 'hero' in broad, loose white strokes, then add color using markers or watercolor. I use a fineliner on top."
—Murray Dewhurst

CHALLENGE YOURSELF

1. ☐ Draw a figure from a photo, using a pencil. Then draw a figure from life, using a pencil. What is different?
2. ☐ Draw a figure from life, in sketchy lines, using a thin nib. Emphasize lines in shadow with a thicker line.
3. ☐ Draw a figure using a brush pen.
4. ☐ Draw a figure using only a brush and paint.
5. ☐ Bring your sketching kit on your next flight and draw whoever you can see, even if it is only a partial view.
6. ☐ Sketch a musician. Take a mental snapshot of the moving parts and draw them, then wait until they take the position again to draw more lines.
7. ☐ Sketch on tinted paper using white gouache or gel pen for highlights.
8. ☐ Sketch someone at work or doing an activity. Be conscious of the shirt and torso as it moves: Catch those creases in the fabric.
9. ☐ Try drawing the negative space around your subject. Think of the body as a puzzle piece, and the negative space, the air around the body, as the piece that fits into it. With no preconceived idea of what that space should look like, you will observe it with more honesty.
10. ☐ Sketch subjects on their phones.
11. ☐ Practice feet in different seasons with different footwear.
12. ☐ Practice weight: Draw a line through the spine and legs for people on your commute, leaning against a wall, standing in a queue.
13. ☐ Draw five figures but only the bodies. Leave out the face. Ask yourself: Where is the weight?
14. ☐ Draw 15 squares. Each row of three should have one of the colors you will use for skin, in different dilutions, from most dilute to least dilute. Try to make them noticeably different!
15. ☐ Practice sketching a group in a café: Draw people in foreground first, then middle, then background. Try it with different inks.
16. ☐ Draw a group watching live music.
17. ☐ Draw a person or a group playing a board, card, or video game.
18. ☐ Use colored pencils for stripes, in broad, fast strokes.
19. ☐ Draw with colored pencils, then paint with watercolor.
20. ☐ Draw people at a market using markers of unrealistic skin colors.
21. ☐ Paint a face, coloring only the shadows.
22. ☐ Paint a face, leaving all the higher points catching the light unpainted.
23. ☐ Take nine colors out with you that approximate those on page 75. See how many colors you can make for clothes, skin, and hair.
24. ☐ Draw a double page of people wearing glasses and sunglasses.
25. ☐ Draw six figures: three in action, three in repose. What is their body language saying?
26. ☐ Sketch the hair of five people, using unrealistic colors.
27. ☐ Draw 10 people with skin in unrealistic tones, using tools you don't usually use.

CONTRIBUTORS

Jenny Adam
Hamburg, Germany
Instagram: @ronkiponk
www.jennyadam.com

Behzad Bagheri
Isfahan, Iran
Instagram: @behzadbagheri.art
www.behzadbagheri.com

Celia Burgos
Cádiz, Spain
www.celiaburgos.com
Instagram: @celiaburgosromero

Gabriel Campanario
Seattle, USA
www.gabicampanario.com

Sylvain Cnudde
Paris, France
Instagram: @sylvaincnudde
Facebook: SylvainCnuddeArt

Mike Daikubara
Charlotte, North Carolina, USA
Instagram: @mikedaikubara
www.linktr.ee/mikedaikubara

Murray Dewhurst
Auckland, New Zealand
Instagram: @kiwisketcher
www.aucklandsketchbook.com

Marielle Durand
Paris, France
Instagram: @marielledurandartist
Facebook: Marielle Durand Dessins
www.marielle-durand.fr

Marta Fonfara
Paris, France
Instagram: @martafonfara
Facebook: mfonfara

Marina Grechanik
Raanana, Israel
Instagram: @marinka71
www.marinagrechanik.blogspt.co.il

Thomas Harry Gunawan
Bandung, Indonesia
Instagram: @thgthgthg
Facebook: Thomas Harry Gunawan
YouTube: thgthgthg

Virginia Hein
Los Angeles, USA
Instagram: @virginiahein
worksinprogress-location.blogspot.com

Oliver Hoeller
Vienna, Austria
Instagram: @hoelleroliver
www.oliverhoeller.com

Omar Jaramillo
Berlin, Germany
www.omarpaint.de
Instagram: @omar_paint

Nina Johansson
Stockholm, Sweden
Instagram: @ninasketching
www.ninajohansson.se

Cathy Johnson
Excelsior Springs, Missouri, USA
Instagram: @kate.cathyjohnson
www.cathyjohnson.info

Uma Kelkar
San Jose, California, USA
Instagram: @umapaints
www.linktr.ee/umapaints
www.umakelkar.com

Sebastian Koch
Berlin, Germany
Instagram: @earthcube
www.sebkoch.de

Lapin
Barcelona, Spain
Instagram: @lapinbarcelona
www.lesillustrationsdelapin

(continued)

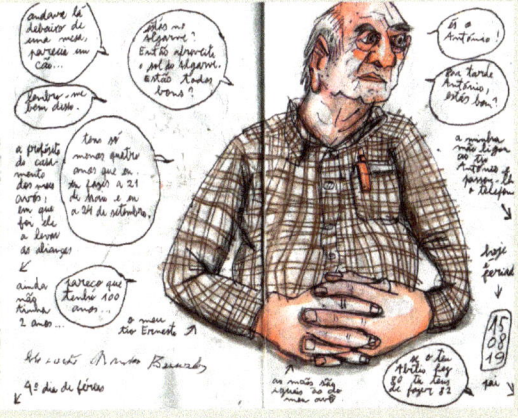

◖ An example of how the pattern of the shirt contributes so much to the individuality of the subject. Speech bubbles are an attractive design element and also tell the viewer about the man.

NELSON PACIENCIA
People and Their Stories

A5 (5¾" x 8¼" | 14.8 x 21 cm);
BIC ballpoint pen 1.6 mm and watercolor pencils.

Mat Let
Paris, France
Instagram @matlet
www.matlet.fr

Mário Linhares
Lisbon, Portugal
Instagram: @linhares.mr
www.hakunamatatayeto.blogspot.com

Pedro Loureiro
Instagram: @pedromacloureiro
www.pedromacloureiro.com

Don Low
Singapore
Instagram: @donlowart
www.donlow-illustration.com

Nicola Maier-Reimer
Hamburg, Germany
Instagram: @nicola.maierreimer
www.maier-reimer.de

Kumi Matsukawa
Kanagawa, Japan
Instagram: @kumimatsukawaart
Facebook: sketcherkumimatsukawa
www.flickr.com/photos/macchann

Paulo Mendes
Porto, Portugal
Instagram: @pauloj.mendes
www.postalguarelas.blogspot.pt

Charline Moreau
Genova, Italy
Instagram: @cmoreauart
www.moreaucharline.wixsite.com/aquarelle-watercolor

Nelson Paciencia
Lisbon, Portugal
www.nelsonpaciencia.blogspot.pt
Instagram: @nelson_paciencia

Rita Sabler
Portland, Oregon, USA
Instagram: @ritasabler
www.portlandsketcher.com

Felix Scheinberger
Berlin, Germany
Instagram: @felixscheinberger
www.felixscheinberger.de
www.felixscheinberger.bigcartel.com

Inma Serrano
Seville, Spain
Instagram: @inmaserranito
www.inmaserrano.es

Suhita Shirodkar
San Jose, California, USA
Instagram: @suhitasketch
www.sketchaway.wordpress.com

John Short
Dublin, Ireland
Instagram: @johnshortartist
www.johnshort.ie

Rob Sketcherman
Hong Kong
Instagram: @robsketcherman
www.sketcherman.com

Detlef Surrey
Berlin, Germany
Instagram: @surrey_sketches
www.surrey.de

Tazab
Clermont-Ferrand, France
Instagram: @tazab

Alfredo Ugarte (Urumo)
Valencia, Spain
Instagram: @alfredo-ugarte-urumo
www.ugarte-urumo.com

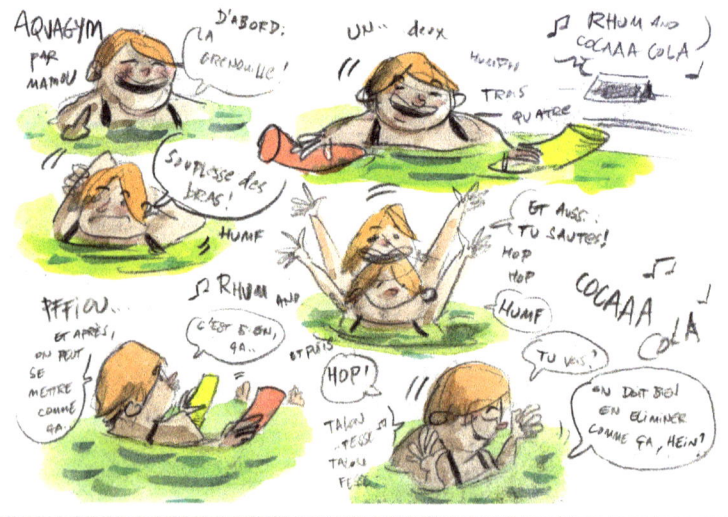

◯ TAZAB
Aquagym for Mamou
A5 (5¾" x 8¼" | 14.8 x 21 cm);
0.5 mm felt-tip pen.

ACKNOWLEDGMENTS

I would like to wholeheartedly thank the artists who contributed their beautiful work to this book with such generosity and grace. It has been a privilege to get to know them through their sketches of the people in their lives. When I was asked to write this book, I was delighted and excited, but it was only when I looked at the work of other sketchers that it dawned on me what a huge privilege it was to have been asked, and I am in great company. I would like to thank my parents, Cinnie and Paddy, for buying all those Asterix and Tintin books, many of which I still have. Thanks are due to the great Posy Simmonds, who showed me that all of human nature could be depicted in a well-observed and skilled line, and who answered when I wrote to her with a question about how she did it. Thanks to Quentin Blake for his invaluable advice about drawing weight all those years ago. Posthumous and eternal thanks are due to the brilliant Brueghel, Hergé, and Uderzo for igniting a spark that continues to burn. I would like to thank my family for their endless patience in keeping still for me even when they wanted to move, and for their initial good intentions when they felt compelled to fidget. I would like to thank Joy Aquilino and the team at The Quarto Group for their patience and guidance. I am so grateful to have been commissioned to write this book. To be asked to show how to depict the most beautiful thing in anyone's life—each other—was to be charged with a sacred task. Last but not least, I thank Gabi Campanario for bringing the miracle that is urban sketching to everyone, everywhere, and the wonderful, warm community of urban sketchers the world over for making this activity of ours such a joy and gift in our lives.

ABOUT THE AUTHOR

Róisín Curé is from Ireland, growing up in the mountains of County Wicklow, and now lives in Galway on the west coast. The paintings of Brueghel and the albums of Tintin and Asterix inspired her early love of the human form in art. She has a background in science (a master's degree in geology) and has taught art to children and adults for over twenty years. It was the discovery of urban sketching in 2012 in Mauritius, where she was spending a few months with her husband's family, that opened her eyes to the huge personal benefits of drawing one's surroundings. She co-founded Urban Sketchers Galway two years later. Since 2015, she has taught urban sketching workshops in Ireland and abroad, including in the USk Symposia in Porto and Amsterdam, and today combines teaching children and adults with private commissions. In 2019, she published her first book, *An Urban Sketcher's Galway* (Currach Press), a memoir of life in an Atlantic town on the edge of Europe.

Brimming with creative inspiration, how-to projects, and useful information to enrich your everyday life, quarto.com is a favorite destination for those pursuing their interests and passions.

© 2021 Quarto Publishing Group USA Inc.
Text © 2021 Róisín Curé
Illustrations © individual artists

First Published in 2021 by Quarry Books, an imprint of The Quarto Group, 100 Cummings Center, Suite 265-D, Beverly, MA 01915, USA.
T (978) 282-9590 F (978) 283-2742 Quarto.com

All rights reserved. No part of this book may be reproduced in any form without written permission of the copyright owners. All images in this book have been reproduced with the knowledge and prior consent of the artists concerned, and no responsibility is accepted by producer, publisher, or printer for any infringement of copyright or otherwise, arising from the contents of this publication. Every effort has been made to ensure that credits accurately comply with information supplied. We apologize for any inaccuracies that may have occurred and will resolve inaccurate or missing information in a subsequent reprinting of the book.

Quarry Books titles are also available at discount for retail, wholesale, promotional, and bulk purchase. For details, contact the Special Sales Manager by email at specialsales@quarto.com or by mail at The Quarto Group, Attn: Special Sales Manager, 100 Cummings Center, Suite 265-D, Beverly, MA 01915, USA.

ISBN: 978-1-63159-931-6

Digital edition published in 2021
978-1-63159-932-3

Library of Congress Cataloging-in-Publication Data

Curé, Róisín, author.
The urban sketching handbook : drawing expressive people : essential tips & techniques for capturing people on location / Róisín Curé.
ISBN 9781631599316 | ISBN 9781631599323 (ebook)
1. Figure drawing-Technique.
LCC NC765 .C87 2020 (print) | LCC NC765 (ebook) | DDC 741.09/04-dc23

LCCN 2020025396 (print) | LCCN 2020025397 (ebook)

Cover Image: Róisín Curé
Page Layout: Claire MacMaster, barefoot art graphic design